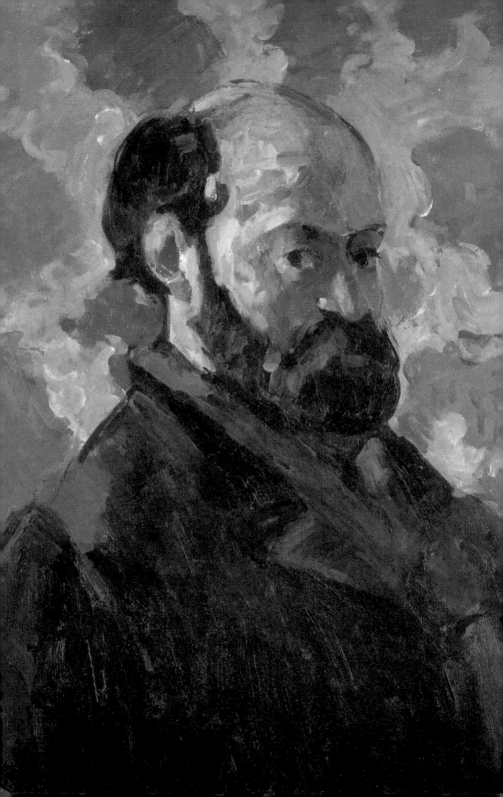

ArtBook Cézanne

DORLING KINDERSLEY

London • New York • Sydney • Moscow

Visit us on the World Wide Web at http://www.dk.com

Contents

How to use this book

This series presents both the life and works of each artist within the cultural, social, and political context of their time. To make the books easy to consult, they are divided into three areas identifiable by side bands: yellow for the pages devoted to the life and works of the artist, light blue for the historical and cultural background, and pink for the analysis of major works. Each spread focuses on a specific theme, with an introductory text and several annotated illustrations. The index section is also illustrated and gives background information on key figures and the location of the artist's works.

■ Page 2: Cézanne, *Self Portrait on Pink Background*, c.1875, Private Collection, Paris.

1839–1870

Childhood and beyond, the formative years

1870–1880

"Cézanne is a dauber"

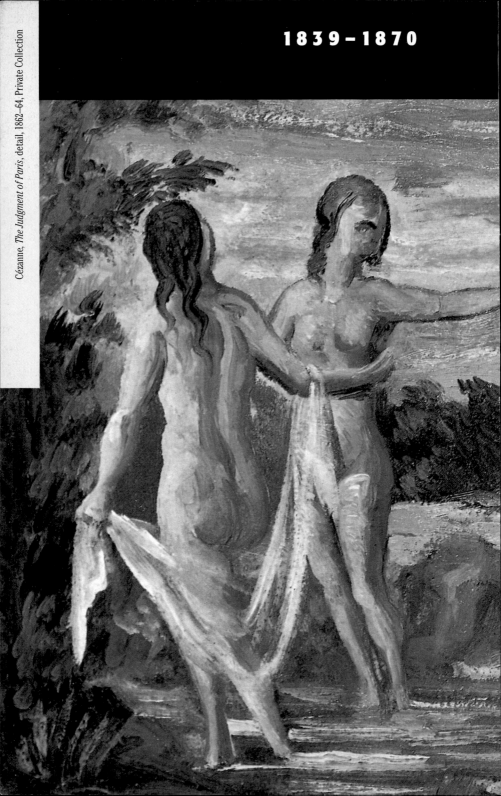

1839–1870

Growing up in Aix-en-Provence

Paul Cézanne was born on January 19, 1839 in Aix-en-Provence, a small town in the south of France. His father's family was almost certainly of Italian origin, in France to seek their fortune. His father was perhaps from a Piedmontese village or perhaps, as Ambroise Vollard, his collector and biographer, has suggested, from the small town of Cesena in Romagna. At all events, by the early 1800s the Cézannes were settled in Aix. Paul's father Louis-Auguste became a hat trader; the felt industry was, at this time, flourishing in Aix and he made enough money to start up a bank in 1848, the Banque Cézanne et Cabassol. Paul spent his childhood in Aix with his parents and sisters. He attended the local primary school and in 1852 went to the Collège Bourbon to complete his studies. He was educated in the atmosphere of a comfortable bourgeois environment. By all accounts Louis-Auguste was a good father even if he insisted on asserting the full weight of his parental authority, occasionally putting obstacles in the way as Paul gradually became aware of his artistic vocation. The family's financial security enabled him to paint without having to rely on selling his work.

■ Before the war, Aix-en-Provence was still a small southern town on the margins of progress. Time had stood still for many years and life was calm and untroubled. The seasons came round in their regular rhythm with the same patterns.

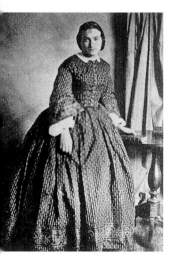

■ Photograph of Marie Cézanne, c.1861. Paul was his mother's favorite child and she encouraged him in his painting. His sister Marie was their father's favorite – he loved her peaceful, calm qualities.

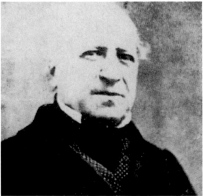

■ Photograph of Louis-Auguste Cézanne. His modest origins, his marriage to a working-class girl, plus the illegitimacy of his first two children were sufficient reasons for Aix society to keep Louis-Auguste at a distance. This had an effect on Paul, who was proud and sensitive, and it deepened his tendency to withdraw into himself.

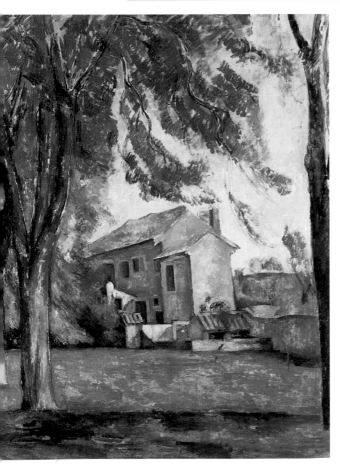

■ François Marius Granet, *Rome: the Basilica of Constantine, the Arch of Titus, and Santa Francesca Romana,* c.1820, Musée Granet, Aix-en-Provence. This painter from Aix, a friend of Ingres, left his fortune and his collections to the museum in his native city. In 1861 part of the museum was dedicated entirely to his work. Cézanne would have known these views, painted by Granet in Italy, and their free, spontaneous style.

■ Cézanne, *Chestnuts and Farm at the Jas de Bouffan,* c.1884, Norton Simon Art Foundation, Pasadena (California). In 1859, Cézanne's father purchased a country house for the summer, the Jas de Bouffan. The large house can be seen in many of Cezanne's paintings, with its row of chestnut trees, the fountain with the dolphin, the stone lions, and walled areas.

1839–1870

Interior with Two Women and a Child

Painted in about 1860, this demonstrates Cézanne's technique, acquired during his studies in Aix. The subject may have come from the women's magazines to which his sisters subscribed. Today it hangs in the Pushkin Museum in Moscow.

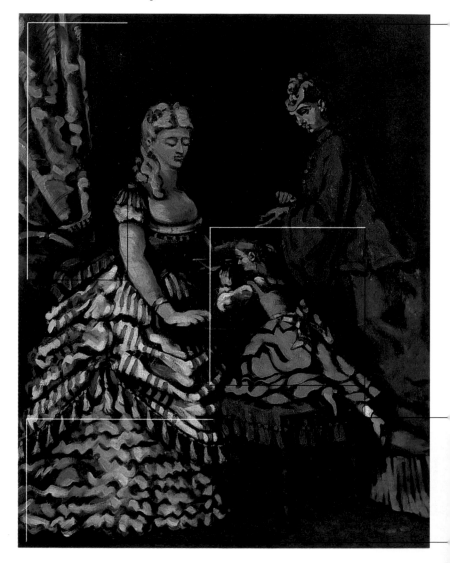

■ Large, round brushes are used to superimpose shades of color on one another from light to dark; the canvas is prepared with a shaded background. The dark tones express the troubled personality of the artist at a very early stage.

■ The use of color seems to be limited here as the bituminous preparation immediately subdues the tones. However, it is easy to identify the three basic colors (magenta red, primary blue, and lemon yellow), in the child's dress, in the bodice and the skirt of the woman. Even though the theme was probably taken from a newspaper, Cézanne imbues it with a certain dramatic tone.

■ In this and in other early paintings, Cézanne used a palette knife and large rounded brushes: the brushes obliged him to structure the canvas in terms of volumes, which simplifies the design.

Napoleon III
crowned emperor

■ This painting shows Napoleon on the battlefield at Sedan on November 7, 1852. With the consent of the French people (the army, the bourgeoisie, the clergy, and the peasants), Louis Napoleon declared himself emperor, taking on the name of Napoleon III.

After the revolutions of 1789 and 1830, France became the natural focus for all the revolutionary movements in Europe. Even the uprising of 1848 became increasingly radical and the repercussions were felt in riots in Germany and revolts against the Bourbon monarchy in Italy. In France opposition to the monarchy, led by republicans and socialists, forced Louis Philippe to abdicate on February 28, 1848. However, once the republic was declared, the temporary government did not provide the real solution to the country's social problems. Introducing universal male suffrage took the electoral numbers to nine million, but the results did not fulfil the democratic ideals of those who had promoted it. Conservative forces held sway over the greater part of the Parisian population, determined to defend the ideal of a republic founded on the reorganization of working practices. In Paris, after a period of revolt, the bourgeoisie and public opinion tried to re-establish order with a presidential regime. In the presidential elections of December 10, 1848, Napoleon I's nephew, Louis Bonaparte, was elected president of the French republic, having gained the support of conservatives, moderates, and the peasant masses still attached to the memory of his great predecessor.

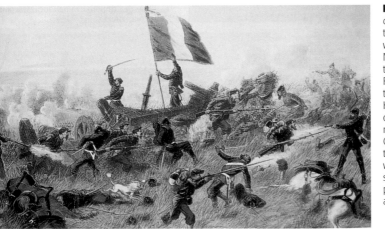

■ This illustration depicts a scene from the Franco-Prussian war. In foreign policy Napoleon III set himself the target of restoring to France the greatness of the era of Napoleon I. However, the formation of a parallel strong national state in Germany led Prussia, the guiding force, into war with France, whose second empire was plunged into defeat and civil war.

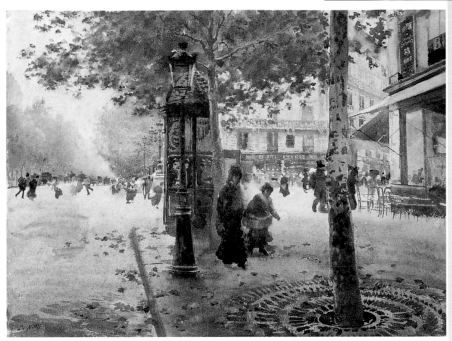

■ Giuseppe de Nittis, *Boulevard Haussmann*, Private Collection, Milan. Napoleon III was firmly behind the development of the economy and of industry, responding to political demands and the rise of an increasingly wealthy bourgeoisie.

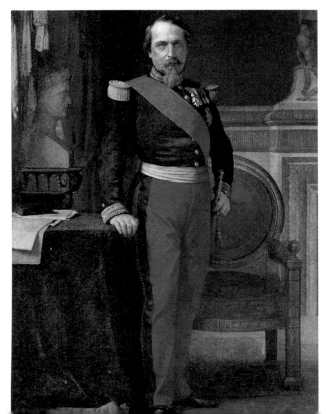

■ The presence of the bust of Napoleon I (on the left) in this portrait of Napoleon III explicitly indicates his desire to continue the glorious Napoleonic tradition half a century earlier, and to restore to the French a sense of pride in belonging to a great power.

1839–1870

The dream of painting

Afer gaining excellent marks in his diploma, Cézanne remained obedient to his father's wishes and joined the Faculty of Jurisprudence at the University of Aix. However, the course did not engage him in the least and letters from this time make bitter allusions to it. Cézanne spent only what time was strictly necessary on his legal studies, in order to devote as much time as possible to writing and drawing. Painting appealed to him more and more and he began to realize that this was his true vocation. In parallel with his university studies, he decided to pursue a course at the École Gratuite de Dessin (Free Drawing School). Cézanne took lessons in life drawing, painting in oils and the faithful rendering of measurement and proportion, and courses in academic drawing. The only subject not taught at the Aix school was the study of nature, even though in 1849 the city museum had acquired a superb collection of canvases painted from nature and donated by François-Marius Granet. The artist had also donated innumerable watercolors, demonstrating an elegant freedom of execution that could hardly fail to touch the young Cézanne.

■ Cézanne, *Male Nude*, 1862, Musée Granet, Aix-en-Provence. The artist made this drawing at the Aix drawing school. In it he reveals great mastery of the technique of academic drawing and a light touch.

■ Cézanne, *Male Nude*, c.1865, Fitzwilliam Museum, Cambridge. Drawn at the Académie Suisse in Paris, this nude differs considerably from the earlier one and reveals a decided personality. The body here is compact, heavier, going against the academic norms of harmony and grace learned at the school in Aix.

■ Cézanne, *Spring*, 1860–62, Musée du Petit Palais, Paris. The panels depicting the *Seasons* were placed in the entrance hall of the Jas de Bouffan. In these early works, made before his departure for Paris, he seems to be reproducing Renaissance paintings.

■ These ink sketches were made by Cézanne in a diary of lessons at the Faculty of Jurisprudence, in about 1859. On December 7, 1858 Cézanne wrote to his friend Emile Zola: "I've taken a fairly tortuous route for the law. Saying "I've taken" is wrong: they have obliged me to take it! That horrible law; ensnared in its circum-locution, it will make my life awful for at least three years!".

■ Cézanne, *Autumn*, 1860–62, Musée du Petit Palais, Paris. The well-defined layout, the precise contours, and the elongated arms explain the ironically placed "Ingres" signature. Ingres was the obligatory model on academic courses.

Portrait of Louis-Auguste Cézanne

Executed in 1866 and now in the National Gallery of Art in Washington, this painting ironically depicts the artist's father reading the daily paper "L'Événement", a newspaper Louis-Auguste detested because of its liberal ideas. In agreeing to pose for his son, he seems to have already accepted Paul's artistic ambitions.

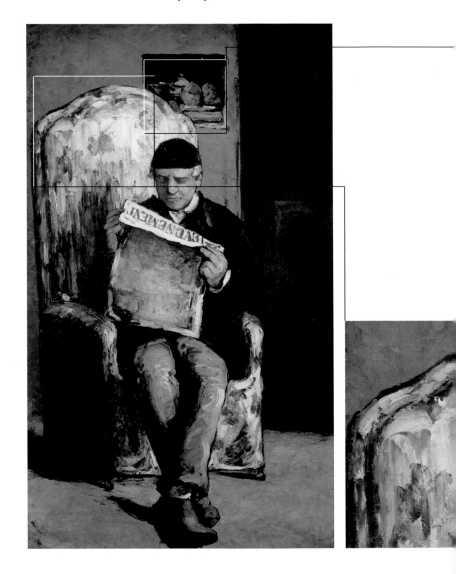

■ From the legs and the large shoes, the planes of the painting push upwards culminating in the small still life on the right, partially hidden by the father's "throne". This detail, with few variations, takes up the *Sugar Bowl, Pears, and Blue Cup* painted by Paul Cézanne in the same year.

■ Cézanne, *Sugar Bowl, Pears, and Blue Cup*, 1866, Musée Granet, Aix-en-Provence. Using a palette knife to spread color, Cézanne juxtaposes thick, irregular dabs to create the fruit and porcelain, in a spontaneous arrangement where color is distributed in wide zones of whites, blacks, and browns which then merge inextricably.

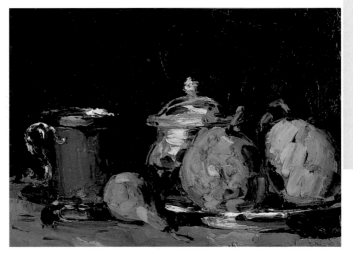

■ The figure of Louis-Auguste is completely immersed in the brightness of the flowered material and the contrast with the black of the hat and coat confirm Cézanne's own saying: "Contrasts do not arise from white or black but from colored sensation".

■ Cézanne, *Portrait of Achille Emperaire*, 1869–70, Musée d'Orsay, Paris. In order to create a certain monumentality around the subject of the portrait, Cézanne used the motif of the armchair once more. "With the air of the pope on the throne" attributed to Emperaire in a letter to Zola from Antoine Guillemet. This characteristic can also be seen in the portrait of Louis-Auguste.

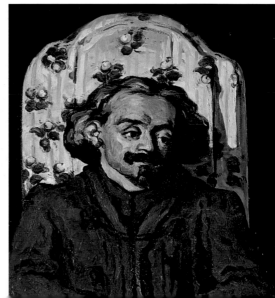

Friendship with Emile Zola

Cézanne and Zola met at the Collège Bourbon in Aix, which they both attended in 1852. Genuine friendship quickly united them. Curiously, in the early years, it was Zola who gained the better marks for drawing and the young Cézanne who displayed a remarkable talent for writing. Both were driven by strong romantic impulses, learning the poetry of Victor Hugo and reading Alfred de Musset. Paris-born but educated in Aix, Zola was fatherless, and Cézanne, the elder by a year, protected him like an elder brother during their school years. It almost seemed like a sign of destiny when Emile gave Paul a basket of apples to thank him for having defended him during a fight at school, anticipating the future artist's favorite theme for still lifes. The correspondence between the two artists, however, reveals a changeable and delicate relationship. Zola was a more worldly and sociable character, while Cézanne was reserved and even tormented. On rare social appearances, Cézanne concealed profound shyness behind a gruff and unfriendly exterior.

■ Cézanne, *Château Médan*, 1879–81, Kunsthaus, Zurich. Cézanne frequently visited Zola at Médan, where he would borrow Nana, Emile's boat, and

■ This letter sent by the young Cézanne to Zola captures happy times spent together in the countryside around Aix during the holidays.

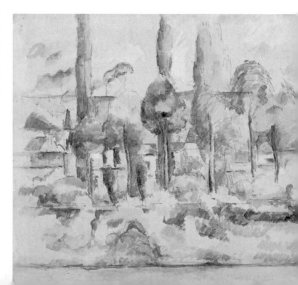

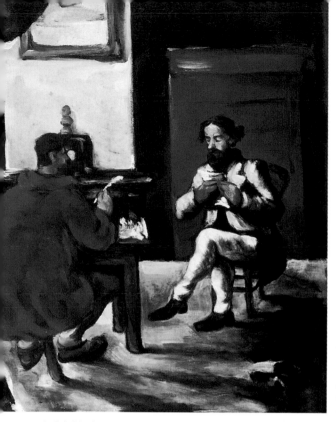

■ Cézanne, *Paul Alexis Reading a Manuscript to Zola*, 1869–70, Private Collection, Switzerland. Left unfinished by the artist, this work lay forgotten for years in the loft at Zola's house at Médan on the Seine. Paul Alexis was a follower of, and then secretary to, Zola, collaborating with him in drawing up the collection *Les Soirées de Médan*, inspired by meetings between the intellectuals and artists of the age.

■ Édouard Manet, *Portrait of Zola*, 1868, Musée d'Orsay, Paris. Zola perceived a sensation of unity and force in the paintings of Manet, an artist he loved "by instinct" and to whom he dedicated many of his critical studies.

go to the little island of Platias on the Seine. Here he was able to paint in peace, away from everyone, appreciating the lovely views over the village.

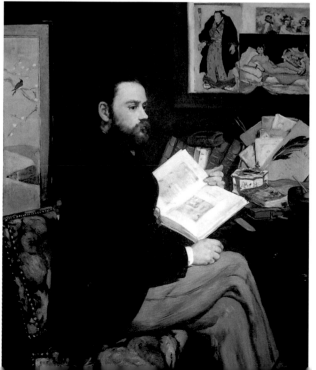

Official culture: the academies and the Salons

The Salon catalogues of this era reveal a disconcerting conservatism in officially approved artistic trends. The subject of a painting (which had to correspond to the values of an increasingly demanding bourgeoisie) was of greater importance than the artistic elements of which it was composed. Color effects were appreciated more than harmony in itself and those who did not bow before these principles had to battle with three enemies: the public, the critics, and the official artists. Models posed in studios where the light source came through the windows, and painters, in order to depict volume, used a gradual transition from light to shade. Academy students drew by studying ancient statues, adding shadows to obtain varying intensities of chiaroscuro. Having learned this method, they then applied it to everything. The public was so used to seeing things represented in this way that they had forgotten that in the open air it is not possible to discern gradations of light and shade. In this regard Edouard Manet and his followers achieved a very real revolution with their discovery that when looking at nature in natural daylight you do not observe single objects, but a mixture of tones which merge before the eye, or rather, in the mind.

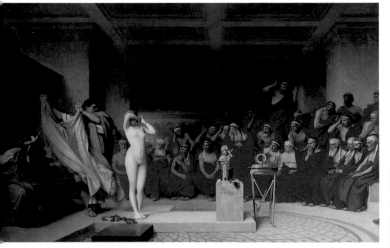

■ Jean-Léon Gérôme, *Phryne before the Areopagus*, 1861, Kunsthalle, Hamburg. Not a single detail is neglected, the smooth pictorial surfaces guiding a taste for art that does not want to be challenged.

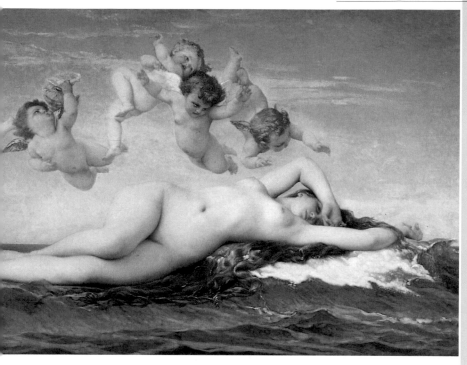

■ Alexandre Cabanel, *Birth of Venus*, 1862, Musée d'Orsay, Paris. This painting, shown at the official Salon of 1863, earned the praise of critics and the public alike, winning the Légion d'honneur for the artist and admission to the Institut des Beaux-Arts. The picture was bought by Napoleon III for its evident sensuality, disguised under the pretext of mythology.

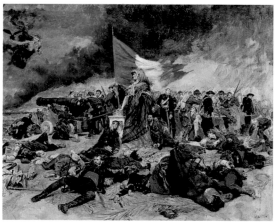

■ George Bernard O'Neil, *Public Opinion*, 1863, City Art Gallery, Leeds. This painting is a comment on the obtuseness of the public who, when visiting exhibitions, want to see their own taste confirmed.

■ Jean-Louis-Ernest Meissonier, *The Siege of Paris,* 1870, Musée d'Orsay, Paris. Meissonier was one of the most important interpreters of the exploits of Napoleon III.

21

1861: Cézanne in Paris

After lengthy discussions with his father, who was probably unconvinced that his son had talent, Paul moved to Paris. Zola had been entreating him to come to the big city and was eagerly awaiting him. However, despite the walks, the visits to the Louvre (where he could admire, among others, Caravaggio, Velázquez, and Veronese), to the Salons, and time spent with his friend, Cézanne became bored. Rejected by the École des Beaux-Arts, his father's preferred school, he attended the Académie Suisse, a liberal atelier where models of both sexes would pose for the artists for a modest sum. Work was neither checked nor corrected. In a letter to Numa Coste, his companion at the drawing academy at Aix, he wrote: "I work calmly, I eat, and I sleep". The Paris trip was important for the young artist, however, as he became acquainted with Camille Pissarro, ten years his senior, who constantly encouraged him and was conscious of the development of his artistic technique.

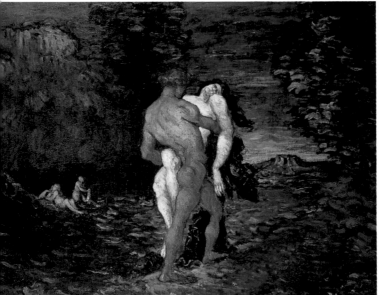

■ Cézanne, *The Abduction*, 1867, Fitzwilliam Museum, Cambridge. This canvas is strongly characterized by the romantic influence of Delacroix. Before it passed into the hands of collectors, it belonged to Emile Zola who, considering his naturalistic ideas, perhaps did not appreciate these romantic excesses.

■ Cézanne, *Medea*, after Delacroix, 1880–85, Kunsthaus, Zurich. This work was inspired by a celebrated painting by Delacroix where Medea, rejected by Jason, takes her revenge by killing their two sons.

■ Cézanne, *Portrait of Delacroix*, 1870–71, Musée Calvet, Avignon. Since the early 1860s Cézanne had harboured a real passion for Eugène Delacroix, constantly quoting him and copying him, even

dedicating to him an *Apotheosis of Delacroix*, the artist ascending to the heaven of the great masters watched by his faithful followers. The project was not however destined to go beyond the sketch stage.

■ Cézanne's relationship with Paris was always to remain difficult and in many circumstances it reminded Paul of his doubts and uncertainties concerning his artistic talent. Pictured here is the church of Sacré Coeur and the monumental stair.

■ Cézanne, *The Negro Scipio*, 1867, Museu de Arte, São Paulo. The "negro Scipio" was a model at the Académie Suisse. He is shown here leaning forward, perhaps caught in a moment of sadness or fatigue. Pissarro praised the painting as a "masterpiece of art".

The Orgy

This work was executed between 1867 and 1872, a period when, Zola noted, Cézanne "was dreaming up immense pictures". It was originally entitled *The Feast* by Cézanne, but was rechristened *The Orgy* by the critics. It is now in a private collection.

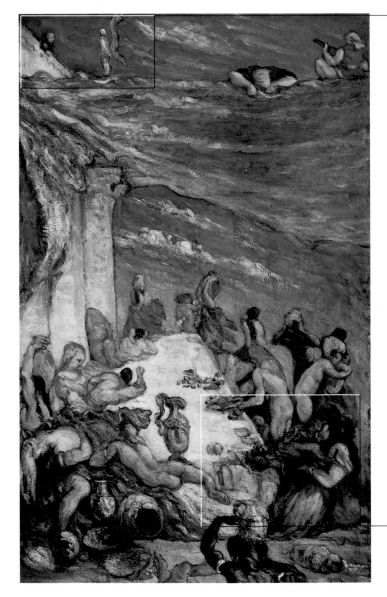

■ The statue at the top on the left and the columns, used by Veronese as theatrical stage wings, are stylized by Cézanne and are only made perceptible by immersing the entire scene in a blue sky, which makes the work look like one great wave of color.

■ Paolo Caliari, known as Veronese, *Marriage at Cana*, 1563, Louvre, Paris. Cézanne admired the work of Veronese, an exceptional colorist and an extraordinary inventor of painted architecture, capable of making the smallest details enchanting.

■ The influence of Veronese and his theatrical "great machines" is clear here from *Marriage at Cana*, which the Veneto artist painted in 1563. Cézanne had often studied and copied the work during visits to the Louvre.

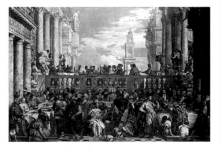

■ The grouping of figures in the foreground shows for the first time the artist's desire to project his own interior conflict on to the imaginary scene, giving form to the lacerating contradictions feeding his own interior battles.

BACKGROUND

1863: the Salon des Refusés

■ Edouard Manet, *Déjeuner sur l'Herbe*, 1863, Musée d'Orsay, Paris. The inspiration for this work came from a contemporary experience: seeing bathers by the Seine, in the suburban village of Argenteuil. The artist realized the painter's dream: placing figures on a natural scale in a landscape.

The paintings that appeared at the Paris Salons represented only a small number of the works presented for appraisal by an extremely rigorous jury, who set out to uphold the supremacy of academic rule. In 1863 the jury was particularly harsh, rejecting over half of the 500 works presented. Discontent among the eliminated artists was so strong that the government and the authorities offered them exhibition space on the Champs-Elysées, where the public could examine their work. The so-called Salon des Refusés rapidly acquired the status of a protest statement against the official institutions, a place where artists in conflict with the authorities could be seen and where the public could go, whether in order to sneer or to enrich their own ideas. This "anti-Salon", which opened on May 15, a fortnight after the official one, attracted crowds of Parisians who flocked there in droves, sometimes as many as 400 people a day. The most important painting shown as regards artistic innovation, outrage to morals and public taste, as well as undoubtedly for the subversive power of its modern and open-minded language, was Edouard Manet's *Déjeuner sur l'Herbe*, which the artist had originally entitled *The Bathe*.

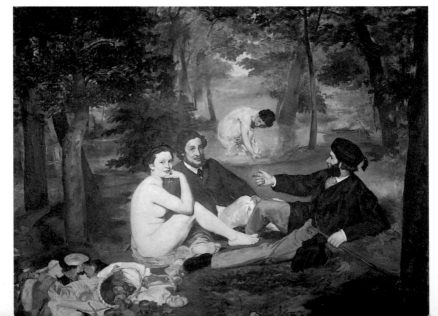

■ Marcantonio Raimondi, after Raphael, *Judgment of Paris*, The Metropolitan Museum of Art, New York. Many of Manet's works, if not directly based on the greats of the past, were inspired by his travel experiences, by reproductions, and by old prints.

■ Edouard Manet, *Olympia*, 1865, Musée d'Orsay, Paris. Inspired by Titian's *Venus of Urbino*, this painting rejects the call of ancient masters, and depicts a woman who, to the public, was none other than a prostitute with an impudent gaze.

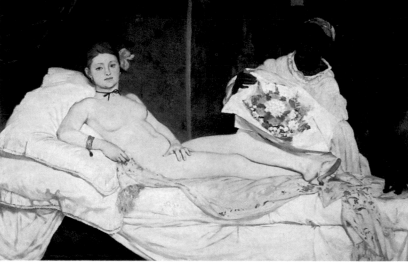

■ Manet's *Olympia* in a caricature by Cham, which appeared in "Le Charivari" in May 1865.

■ James McNeill Whistler, *The White Girl*, 1862, National Gallery of Art, Washington. When Whistler's painting was shown at the Salon, an American critic noted that the woman "is standing on a wolfskin rug, one does not know why".

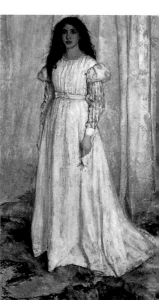

1839–1870

Achille Emperaire

This canvas, painted between 1869 and 1870, is a portrait of Achille Emperaire, a native of Aix, Cézanne's senior, and, like him, a painter. It is now in the Musée d'Orsay in Paris.

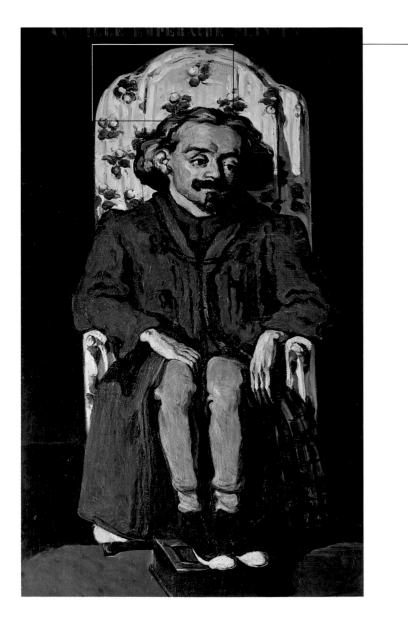

■ Cézanne makes the out-of-proportion body of the dwarf into a monumental figure, who reigns over a background that can also be seen in other paintings; in the portrait of his father the artist used the same flowered cover for the armchair.

■ This caricature by Album Stock, represents Paul Cézanne and two of his paintings, refused by the Salon of 1870. Cézanne told the journalist, Stock, "I, I dare, dear Monsieur Stock, I dare…I have the courage of my opinions".

■ Cézanne, *Achille Emperaire*, 1869–70, Kupferstichkabinett, Basel. "A burning soul with nerves of steel, an iron pride in a misshapen body, a flame of genius in a crooked hearth", thus Cézanne remembered Emperaire.

■ Cézanne, *Achille Emperaire*, 1869–70, Musée du Louvre, Paris. Despite his deformity Emperaire had "a magnificent cavalier's head": a high domed forehead and long hair, so that the artist found expression through the handsome face and the long, thin, tapering hands.

The grandiose projects of Napoleon III

Napoleon III decided to stimulate the French economy in order to satisfy the growing needs of the haute bourgeoisie as well as to improve the living conditions of the working class. The process of industrialization involved the whole of France: ports were built, as well as canals and railways, new mines were opened up and the building trade expanded. The expansion resulted in giving the French bourgeoisie an absolutely pre-eminent role in the economy, and the mass of the proletariat began to demand their rights. The worker's right to strike was granted in 1864 and there was an increasing call to form workers' associations founded on self government and individual liberty. To marginalize possible social conflict, Napoleon III decided he needed to establish the basis for a great French colonial empire. So during his reign France consolidated rule over Algeria, conquered new bases in Senegal and Somalia, and started the colonization of Indochina. This ambitious foreign policy had the primary object of regaining supremacy for France in Europe. However, when expansion was confronted by strong, compact national states, the strategy weakened rather than strengthened the personal power of Napoleon III.

■ The Champs-Elysées in the mid-19th century in an engraving by Champin, Pushkin Museum, Moscow. The long boulevards criss-crossed in star-shaped *ronde-points* creating charming perspective views.

■ Camille Pissarro, *Avenue de l'Opéra*, 1898, Pushkin Museum, Moscow. L'Avenue de l'Opéra, opened up as part of Georges-Eugène Haussmann's imposing transformations, was one of the most frequently recurring scenes in Impressionist painting. Cézanne, however, never really succeeded in putting down roots in the *ville lumière* and was to find himself increasingly at ease away from the city.

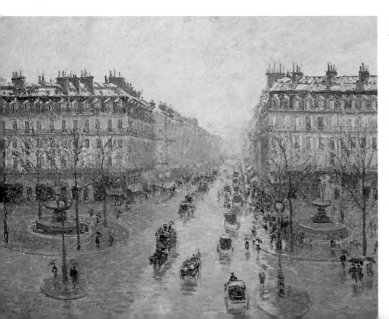

Haussmann and the Ville Lumière:

Napoleon III wanted to turn Paris into a modern, grandiose capital, as envisaged by Bonaparte. To this end Georges-Eugène Haussmann, prefect from 1853 to 1869, demolished the old medieval quarters of the city, opening up grand *boulevards*, building wide squares and creating new suburbs. Another important problem of public order was solved at the same time: the layout allowed for strict, rapid military control in the event of uprisings. Paris became the "ville lumière".

■ Cézanne, *The Wine Depot Seen from rue Jussieu*, 1872, Private Collection. For some time Cézanne lived in a modest apartment at 45 rue Jussieu. The Paris he saw and experienced was not the Paris of his artist friends, who painted picturesque views of the city center thronging with people.

■ Haussmann was seen as the "artist-demolisher", the first to carve out the ancient past from the center of a big city and design new quarters for the future.

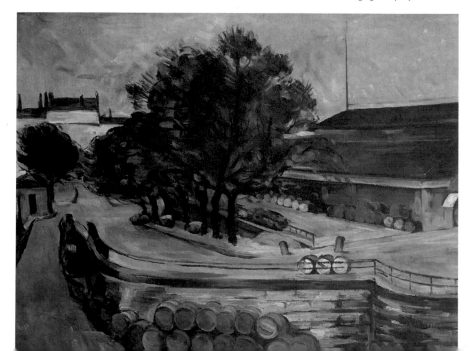

BACKGROUND

Nadar and the birth of photography

The identity of the true father of photography has long been the subject of heated debate among students of the subject. However, the official presentation of 1839 claims that Daguerre was the first to develop an effective photographic method. Gaspard-Félix Tournachon, better known by his pseudonym of Nadar, was considered one of the most eccentric figures in the field of photography, and he also exerted a considerable influence on painting in the second half of the 19th century. His personality is manifest in caricatures for journals and magazines, which immediately reveal a lively critical spirit and keen observation. In 1854, he opened a studio at 113 rue Saint-Lazare, Paris, dedicating himself in the main to the type of portrait produced by making the most of the light conditions in his studio. Using a radiant light source, facial expressions were modelled by shadow, an effect highlighted by the complete absence of any painted background. Nadar also took several aerial pictures, photographing parts of Paris from a hot-air balloon. Artists were able to discern asymmetries, oblique lines, and partial views in the aerial images, a new way of seeing and perceiving reality.

■ Nadar, *Pantheon*, 1854. With the artistic and literary climate in Paris in mind, Nadar was initially drawn to photography as a way of producing a lithograph in which he could bring together the faces of 270 famous personalities. To create this work he produced countless portraits, drawings, and caricatures.

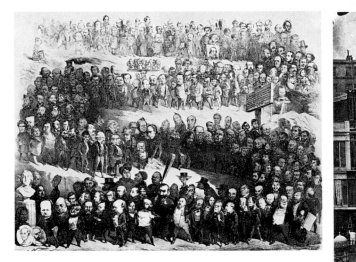

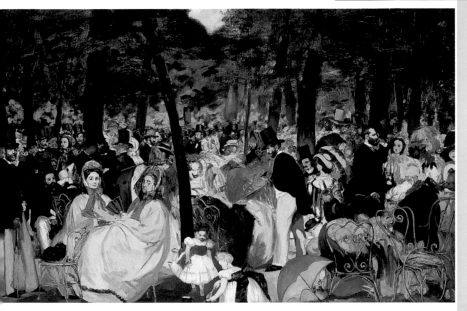

■ Edouard Manet, *Concert in the Tuileries Gardens*, 1862, National Gallery, London. The blurring and unusual cropping of the figures in Manet's painting creates a feeling of movement, rather like a snapshot composition.

■ This intense portrait of Ernestine, Nadar's wife, dates to about 1900. A striking feature of the photographic method is the ability to produce a faithful image, and at the same time convey expressive force. The result in this case is touching.

■ The first Impressionist exhibition was held in 1874 at number 35, Boulevard des Capucines, in the rooms of Nadar's old studio (shown here in a photo from 1860).

■ Taken by Nadar, this photograph portrays the chemist Eugène Chevreul, aged 100. He wrote an important text on the behaviour of color which provided a theoretical base for Impressionism.

Overture to Tannhäuser

This canvas, painted in about 1869 and inspired by Wagner's music, was given to his sister Rose, who may have posed for the painting. It stayed with her until it was sold to Ambroise Vollard and is now in the Hermitage in St Petersburg.

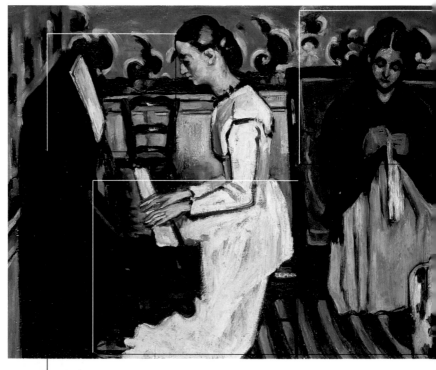

■ The subject of *Tannhäuser* comes from the legends of Christian Germany and takes the theme of redemption through love. Tannhäuser, cavalier and poet, is caught in the nets of Venus and condemned to eternal punishment, from which not even the Pope will absolve him; he is saved by the love of Elizabeth who dies in order to save him.

■ There are several versions of this painting, and this is probably the latest. Cézanne depicts a moment of bourgeois intimacy. Previous attempts showed male figures, while here the construction is entirely feminine: the young woman at the piano and in the background, another woman sewing. As in other works and particularly in portraits and still lifes, Cezanne has depicted a background with geometric patterns, creating a bolder definition of space.

■ Cézanne shows us a woman mending and a woman playing, perhaps dreaming of an artist's life. Like Elizabeth and Venus, each is absorbed in her own world, so close and yet so distant, each giving the other space for her own individual talent.

Daumier and caricature

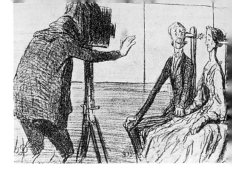

Paul Cézanne declared: "Though very young when confronted with reality, I was passionate about Daumier". Born in Marseille the son of a glazier, Honoré Daumier moved to Paris with his family in 1816. Like Cézanne, he attended the Académie Suisse and at the beginning of his career was mainly preoccupied with lithography and drawing. Initially he collaborated on "La Caricature", but the ferocious political attacks to which his pencil gave voice in the magazine provoked immediate condemnation, which would contribute to its closure. The challenge to censorship however immediately began again with a new publication called "Le Charivari", in which Daumier published a series of incisive political and social caricatures. The young artist displayed sureness of hand, liveliness of line and, according to the prevailing fashionable science, precision in physiognomy. Seeing his intense figures, no bigger than a fist, Balzac, literary editor on the magazine for which Daumier was the illustrator, spoke of him as a "new bourgeois Michelangelo" in Paris. Echoes of Michelangelo come from the plastic force, moral passion, realism, and vision.

■ Subjects who posed for a photographic portrait had to remain still for at least 20 minutes. In 1840 Daumier published a series of lithographs ridiculing the lengthy posing time, titling one of them *Patience is a virtue in asses*.

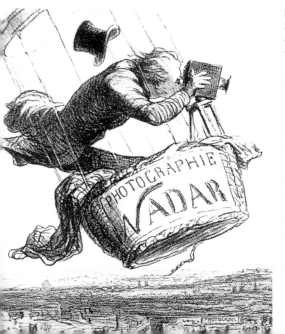

■ Honoré Daumier, *Nadar elevates Photography to the Status of an Art*, 1862, Museum of Fine Arts, Boston. Daumier published this lithograph in which Nadar is at work in a hot-air balloon: every building carries the word "Photography".

■ Jules Chéret, *Poster for a Palais de Glace*, 1894, Bibliothèque des Arts Décoratifs, Paris. Chéret's posters reveal his compositional dynamism and brilliant combinations of color.

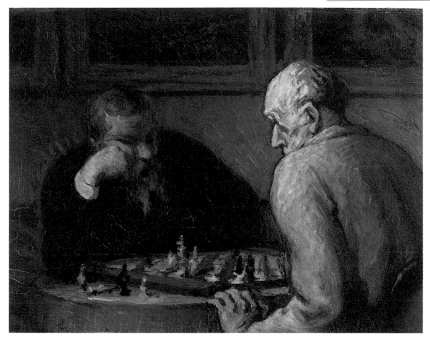

Posters

The numerous technological innovations of the 19th century ran parallel to the emergence of the publicity poster: in particular the introduction of new techniques like lithography and especially chromolithography (1836), producing a color print through an impression on stone sheets and different inking. After the first chromolithographic experiments using two colors, the artist Jules Chéret (1836–1932) perfected the techniques, producing a series of color posters in 1866. Large posters, known as *affiches*, were characterized by attractive illustration and original, showy lettering. As society became more industrialized, it was increasingly important that the poster be brief and psychologically persuasive: the text concise and the design captivating.

■ Honoré Daumier, *The Chess Players*, Musée du Petit Palais, Paris. As can be seen elsewhere, Daumier chose to show the figures in three-quarter length, enabling him to pay attention to gesture and facial expression.

■ Honoré Daumier, *The Print Lovers*, Boymans-van Beuningen Museum, Rotterdam. These figures, perhaps real people, with their intent absorbed gaze, represent universal figures.

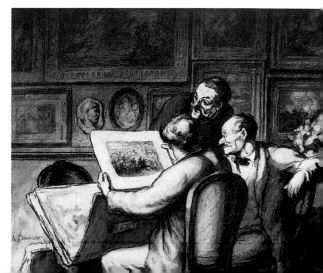

1839-1870

Cézanne and Flaubert

Claude Monet described Cézanne as "the Flaubert of painting". In fact the artist was so fascinated by the writer that he identified him with a color, somewhere between the red and blue that characterize *Old Woman with a Rosary*. Both men had experienced lengthy and tormented creative periods and held similar artistic theories. Like Cézanne in painting (especially in his early work), Flaubert tended to repress the "romantic" tendencies in his temperament, trying in his novels to combine, the realistic and the imaginative. Similarly, Cézanne was inspired by orgiastic themes (*The Orgy*), images of seduction (*Afternoon in Naples*), and demoniacal images (*The Temptations of St Anthony*, 1870, Fondation E. G. Bührle, Zurich). All themes characteristic of Flaubert's novels, and all showing Cézanne's close proximity to the writer. Flaubert felt the crisis of bourgeois society traumatically, the defeat of individual values and the degradation caused by conformity, more so than Cézanne, who right from the beginning preferred to withdraw in solitude. This disgust was to get the better of the analytical scruples that increasingly characterized Cézanne's paintings.

■ Taken by Nadar in 1870, this photo is of Gustave Flaubert, who described by Maxime du Camp was "young, very tall, very robust, with large prominent eyes, full eyelids, plump cheeks, coarse, drooping moustaches, and lively coloring".

■ Cézanne, *Afternoon in Naples*, 1875–77, National Gallery of Australia, Canberra. As elsewhere the painter uses the typical trappings of seduction in an image which seems to be "drenched with perfumes".

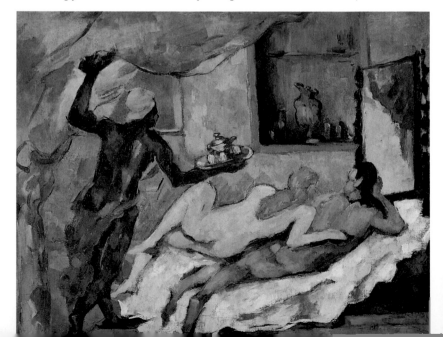

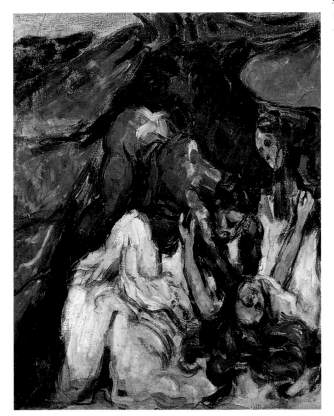

■ Cézanne, *The Strangled Woman*, c.1872, Musée d'Orsay, Paris. This may be a depiction of a terrifying real event. It appears that Cézanne wanted to punish a certain type of woman different from the controlled, middle-class women seen in *Overture to Tannhäuser*.

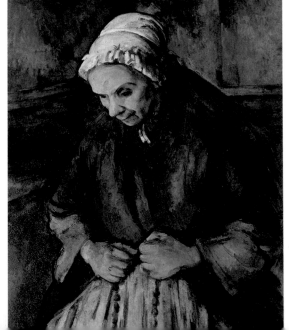

■ Cézanne, *Old Woman with a Rosary*, 1895–96, National Gallery, London. Cézanne wrote in a letter: "when I painted my old woman with a rosary, I saw a Flaubert color. This grand blue russet seduced me, sang to me in my soul".

Balzac and *The Unknown Masterpiece*

This celebrated novel by Honoré de Balzac was better known to artists than to the general public: to Matisse, and to Picasso who in 1931 illustrated an edition, and above all to Cézanne, who was so affected by it that he identified himself with the figure of Frenhofer who, in his "perennial search for reality, fell into darkest obscurity". Frenhofer, the most well-known French painter of the 1600s, worked for years on a canvas without ever managing to finish it. Commenting on the novel, Picasso wrote: "There are so many different realities, and in wanting to embrace them all, you fall into the darkness".

Cézanne, *Bathers*, detail, 1874–75, The Metropolitan Museum of Art, New York.

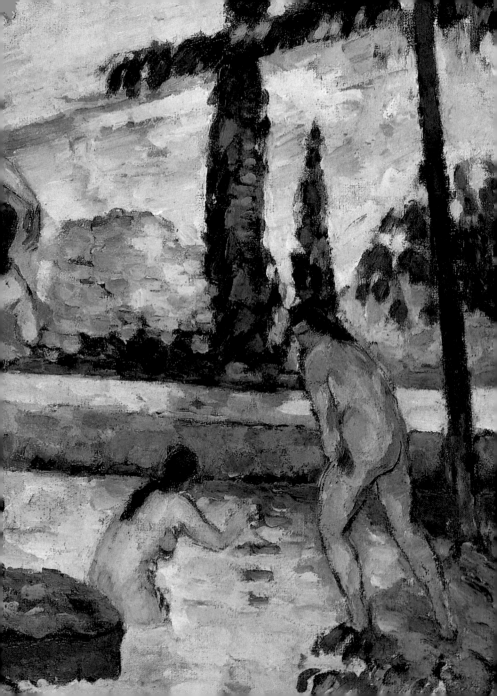

1870–1880

Meeting with Hortense Fiquet

After a period of isolation at Aix, Cézanne returned to Paris in the winter of 1869. It was roughly at this time that he met Hortense Fiquet, a young model, 19 years old, from Sauligny in the Jura. Hortense was tall and lovely, brown-haired, with big dark eyes and clear skin and Cézanne, 12 years her senior, fell in love. They decided to live together in secret, keeping their relationship hidden. Even after the birth of their son Paul they kept the news from the family and above all from Cézanne's father Louis-Auguste, who would never have accepted a union between his son and a girl without a dowry. These changes in Paul Cézanne's life remained in the private sphere and did not affect his art or his relationships with old friends. It appears that Hortense was, in Cézanne's own words, frivolous and a little superficial, she "only loved Paris and lemonade". She was, however, an available and patient model, frequently pictured in a wide variety of poses, increasingly abstract and remote, with extremely modern effects of studied, formal simplicity.

■ Cézanne, *Studies and Portraits of the Artist's Son*, 1878, Albertina, Vienna. Little Paul was born on January 4, 1872. Among the numerous portraits Cézanne made of his son, few are as touching and revealing of the joy the child gave him.

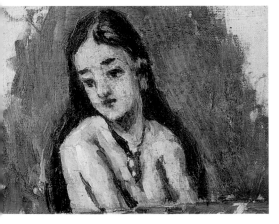

■ Cézanne, *Girl with Loosened Hair*, 1873–74, Private Collection. This small portrait, for which Hortense may have posed, is one of the rare studies in oils for future compositions with groups of bathers.

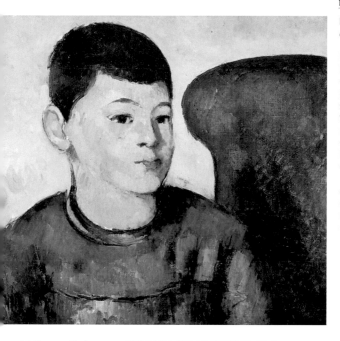

■ Cézanne, *Portrait of the Artist's Son*, 1883–85, Musée National de l'Orangerie, Paris. Until 1880 Cézanne only drew pencil sketches of his son, unable to force the boy to sit for long periods. From 1880 onwards however, Paul appears in some oil paintings and in 1888 he posed dressed as Harlequin in the celebrated *Mardi Gras*, now in the Pushkin Museum in Moscow.

■ Cézanne, *Madame Cézanne in the Conservatory*, 1891–92, The Metropolitan Museum of Art, New York. Hortense sat regularly for her husband. Twenty-four painted portraits are known of her (mainly three-quarter length) and dozens of drawings. This is one of the most famous pictures of Hortense. Background and foreground are unified by the curve of the trunk and the arms. The painting, which was never finished, expresses grace and elegance with originality.

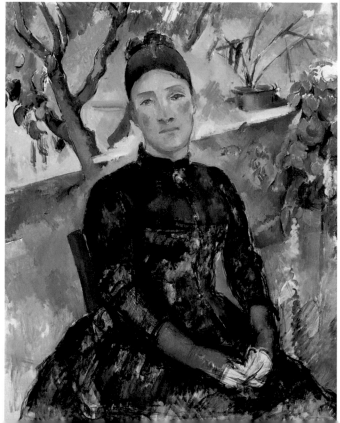

1870: the outbreak of the Franco-Prussian war

After the failure of the liberal and democratic revolution of 1848, the need to unify the German states was rendered even more pressing. In the second half of the century industrial growth turned Germany into the most economically developed country on the Continent. The process of unifying the German states followed the Prussian model: it was in fact directed from Prussia by Kaiser Wilhelm I and by his energetic and authoritarian chancellor, Prince Otto von Bismarck, via a series of swift wars and annexations. After a successful battle for the expulsion of Austria from Germany (the Hapsburgs had always been an obstacle to the unification of the German states) Prussia saw her power increase considerably. The France of Napoleon III watched with misgiving as a powerful German confederation driven by Prussia began to form in the heart of continental Europe. France also saw that a consequence of unification was the presence of a very dangerous neighbor on her eastern border. On his side, Bismarck regarded war with France as inevitable but sought to make France appear as the aggressor, even introducing conscription in the name of German nationalism and obtaining the necessary internal consent. In 1870, Napoleon III fell into the trap – in an atmosphere of high tension created by the nationalist opposition – and on July 19, he declared war on Prussia.

■ A descendant of an old aristocratic family belonging to the landed Prussian nobility, Otto von Bismarck (pictured above) had a profound sense of the importance of the state and the clear intention of making Germany great and powerful.

■ On September 4, 1870 the French population called for the abdication of Napoleon III, after the defeat at Sedan. The illustration shows the crowd invading the Chamber, calling for the proclamation of a Republic.

■ This cartoon shows brigands and Napoleon III trying to keep the temporal power of Pius IX upright.

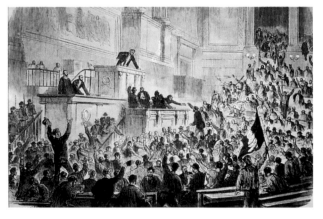

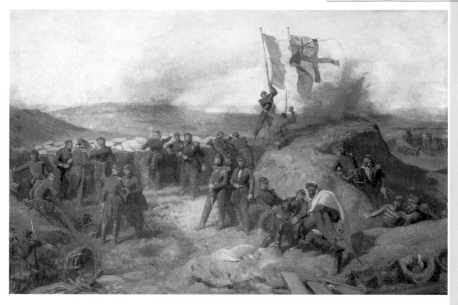

■ The Prussian army, better equipped and organized, defeated the French army at Sedan on September 2, 1870; French troops and Napoleon III were forced to surrender.

■ Pierre Puvis de Chavannes, *The Balloon*, 1871, Musée d'Orsay, Paris. The war left artists with a profound sense of sadness and loneliness.

1870–1880

House of the Hanged Man

Cézanne produced this painting in about 1873 and presented it at the first Impressionist exhibition in 1874. It is considered a key work in his artistic career. Thanks to the bequest by Comte Isaac de Camondo, it is now in the Musée d'Orsay in Paris.

■ The view of Auvers is just visible between the two houses in the foreground and, as though through the eye of a needle, the viewer's gaze is drawn towards the village in the background. Three parallel planes mark the foreground, middle ground, and background, the planes unified by the even distribution of light.

■ The wall on the left holds the gaze of the viewer, unlike most Impressionist paintings where the spectator's eye is drawn to the background through the use of perspective.

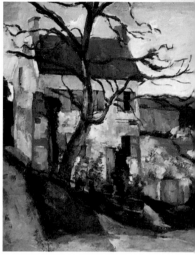

■ Camille Pissarro, *The Hermitage road at Pontoise*, 1874, Private Collection. Pissarro taught Cézanne that it was not necessary to dwell upon linear forms, because they could be rendered by another means: through color.

■ The thick, grainy spread of paint demonstrates his intention to create solid forms. The cabin on the right seems almost incidental, in contrast with the red and black roofs of the village in the background.

Artists and the war

■ Claude Monet, *Gare Saint-Lazare*, 1877, National Gallery, London. This painting may have been influenced by a Turner painting, *Rain, Steam and Speed. The Great Western Railway*, which Monet had seen during his exile in London.

R eactions of artists to the Franco-Prussian war varied at the time. Manet, Degas, and Renoir enrolled in the army. Pissarro stayed in Louveciennes until the Prussian forces arrived, then escaped to England, as did Monet. Cézanne left Paris and after a brief period spent in Aix-en-Provence, he moved to l'Estaque near Marseille with Hortense and his young son Paul. On January 5, 1871, the Prussians began bombarding Paris. The atmosphere in the capital became tense: food reserves were running out and hunger and epidemics were taking hold. In a letter to his wife, Manet wrote that in the absence of food they were eating cats, mice, and dogs and only a few fortunates were able to get hold of horse meat. In London meanwhile, Monet and Pissarro met up frequently and the experience was to be fruitful to both. English painting, especially the work of J.M.W. Turner and John Constable, was to have a significant influence on their art. Also in London at this time was Paul Durand-Ruel, an important collector and art dealer who opened up a gallery in New Bond Street with a substantial collection of paintings by French artists.

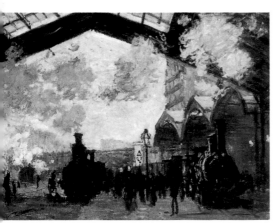

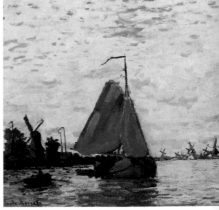

■ Claude Monet, *The river Zaan at Zaandan*, c.1871, Private Collection. Before his final return to France from England, Monet went to the Netherlands, attracted by the picturesque windmills and by the hugeness of the sky over the flat countryside, by the canals and river traffic and by the towns with houses which appeared to be constructed right on the water. After this "nordic" experience, the luminosity in his paintings grew more intense.

■ Camille Pissarro, *Field at Hampton Court*, 1891, National Gallery of Art, Washington. Pissarro said: "Monet and I were full of enthusiasm. We worked from nature… but also went to the museums".

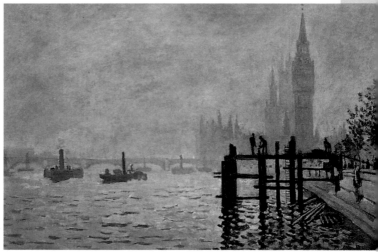

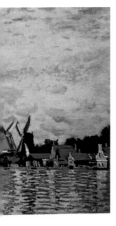

■ Claude Monet, *The Thames and the Houses of Parliament*, National Gallery, London. This was painted in 1871 while Monet was a refugee in England, where he arrived just after the outbreak of war in 1870. The foggy skies of London were the subject of a number of studies on subsequent trips to English soil.

1870–1880

Meeting Pissarro at Auvers-sur-Oise

Auvers-sur-Oise is a small village 30 kilometers (18½ miles) from Paris, now famous as the place where Vincent van Gogh committed suicide. Surrounded by hills and valleys, Auvers gave painters the opportunity for reflection and painting *en plein air*. Cézanne moved here with his family and stayed as a guest of Dr Paul-Ferdinand Gachet, a homeopathic doctor, art lover, and friend of Pissarro. Dr Gachet loved entertaining friends, and the two men held long conversations about art. The doctor also provided visiting artists with the equipment necessary for producing etchings (slabs, press, and copperplates), which Cézanne was to try out here for the first and only time in his life. Auvers was a turning point for the artist: in close contact with Pissarro, Cézanne abandoned fantastic, visionary themes and gloomy views of Paris, and his color range became lighter and brighter. His palette knives were no longer large and squared but thin and flexible, so that he was able to paint using little dabs and touches of color, with wonderfully harmonious results.

■ Vincent van Gogh, *Cornfield under a Stormy Sky*, Van Gogh Museum, Amsterdam. On July 27, 1890 Vincent shot himself in a cornfield at Auvers, about two months after his arrival.

■ Camille Pissarro, *The Red Roofs*, 1877, Musée d'Orsay, Paris. Where Pissarro delineated forms with brief brushstrokes, capturing atmospheric vibration, Cézanne "constructed" and moulded the landscape with dense, mellow color.

■ Camille Pissarro, *Portrait of the Artist*, 1873, Musée d'Orsay, Paris. Cézanne felt affectionate esteem for Pissarro.

■ Camille Pissarro, *Hoar Frost*, 1874, Musée d'Orsay, Paris. In a letter to his friend Zola, Cézanne told him that the countryside was indeed extraordinary. "I see superb things and I need to decide to paint solely *en plein air*". Pissarro wrote to his son explaining the nature of their work: "Everyone took the idea to heart that they must preserve the only thing that counts, one's own sensation".

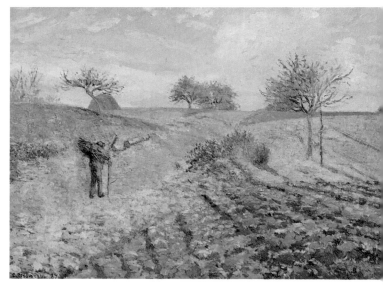

■ Cézanne, *View of Auvers-sur-Oise*, 1873, The Art Institute of Chicago. Cézanne was not concerned with reproducing the land-scape with precision, but translated the *sensations* which he derived from the place into an artistic image.

51

The Third Republic and the Commune

■ *The Burning of Paris, 24–25 May 1871*, watercolor, Musée Carnavalet, Paris. Supporters of the Commune shot the archbishop of Paris along with other hostages, and before submitting to Thiers they set fire to symbols of bourgeois power like the Stock Exchange and the Palais des Tuileries.

Nﾠews of the defeat of Napoleon III had barely reached Paris, when the Republican opposition proclaimed a republic and formed a government of national defence in an attempt to salvage the provinces and the capital. The new republic was however quickly forced to call for armistice: a national assembly elected by universal suffrage decided to ask for peace and formed a new government headed by Adolphe Thiers. On May 10, 1870 France gained peace but had to cede Alsace and part of Lorraine to Prussia as well as pay a heavy war indemnity. Meanwhile the collapse of the Second Empire spurred the population of Paris into extreme revolutionary fervour. Their aim, promoted by Blanqui and Proudhon, was to substitute a centralized state with a federation of communes based on popular self government. The Parisian population elected a new city administration, the Commune, with legislative and executive power and formed commissions elected directly by the workers. The civil war between the insurgents and the conservative government went on for another two months and was carried out with pitiless harshness, but still more ferocious in the end was the repression of Thiers.

■ Sabatier, *The Column in Place Vendôme, Brought Down on 16 May 1871*, Musée d'Art et d'Histoire, Saint-Denis. The destruction of the column had symbolic significance.

■ Edouard Manet, *Civil War*, 1871, The Art Institute of Chicago. Confronted with the violence of the class war, modern Europe was overtaken by a wave of horror that led the international organization of working men to attempt to destroy the bourgeois state.

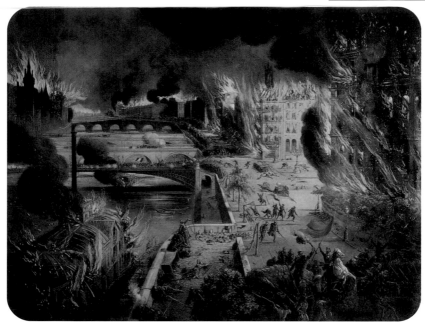

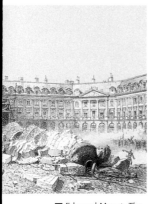

■ Edouard Manet, *The Barricade*, 1871, Pushkin Museum, Moscow. Manet's experiences of living through the siege of Paris became a source of inspiration for the painter and he produced several lithographs, among them this one, engraved on the battle site itself.

LIFE AND WORKS

L'Estaque

L'Estaque is a fishing village in the bay of Marseille and Cézanne stayed there at various times in his life. In September 1870, during the Franco-Prussian war, Cézanne took refuge there with Hortense and his son Paul. "During the war I worked a lot from nature at l'Estaque. I divided my time between the countryside and the studio", he was later to relate to Vollard. The little village made a fascinating subject and he increasingly pursued a style using extremely elegant construction and geometric experimentation, tending to exclude volume. Cézanne produced 27 canvases inspired by l'Estaque, with its buildings of brick, tiles, and cement, their pointed chimneys revealing pre-Cubist glimpses and even Braque-like portraits. In a letter to Pissarro in 1876, the painter described the countryside as a playing card with its "red roofs against a blue sea…. The sun here is so tremendous that it seems to me as if the objects are silhouetted not only in black and white but in blue, red, brown, and violet".

■ Cézanne, *The Bridge at Maincy*, 1879–80, Musée d'Orsay, Paris. This is one of the pictures regarded as "constructive" by critics, in which long wide brushstrokes weave in and out forming a sensual and subtle composition.

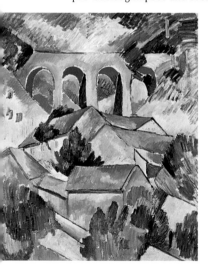

■ Georges Braque, *Viaduct at l'Estaque*, c.1908, The Minneapolis Art Museum. Cézanne's example of simplification was much followed.

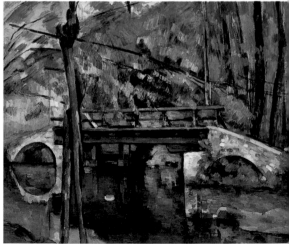

■ Cézanne, *Roofs at l'Estaque*, 1878–82, Museum Boymans-van Beuningen, Rotterdam. This delicate watercolor, with its harmonious colors, looks over a panorama of roofs, permitting a glimpse in the background, opposite the bay, of the mountain chain which rises south of Marseille. Watercolor is the medium that most faithfully translates the emotion of the moment.

■ Paul Klee, *The Niesen*, 1915, Kunstmuseum, Bern. Klee makes use of a Cézanne-style motif in this composition, making the foreground and the Bernese mountain geometric.

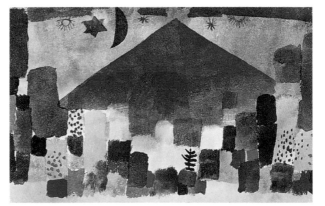

■ Cézanne, *The Sea at l'Estaque*, 1878–79, Musée Picasso, Paris. The horizon dissolves on the left, making the line between sky and sea indistinguishable.

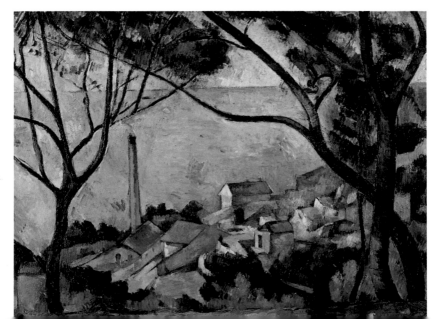

1870–1880

Three Bathers

This painting dates from about 1875. For many years prior to being placed in a private collection, it belonged to the sculptor Henry Moore. Three women are shown around a fountain, two of them playing games with the spray.

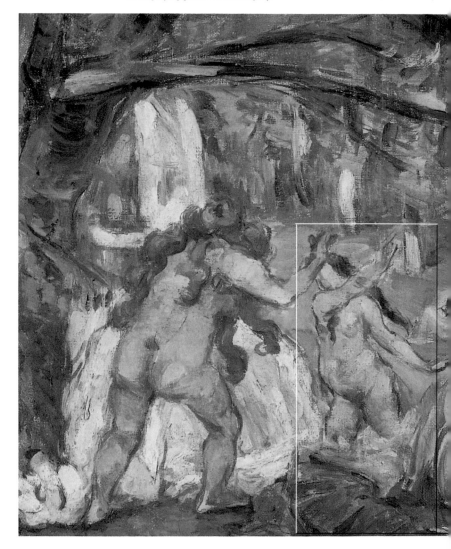

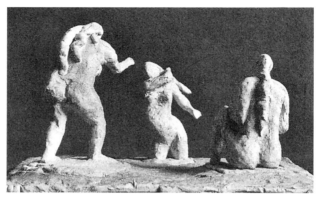

■ Henry Moore, *Three Bathers, after Cézanne*, 1978, The Henry Moore Foundation, Hertfordshire. The sculptor produced these small sculptures taking the three bathers as the starting point.

■ Adolphe-William Bouguereau, *Birth of Venus*, 1879, Musée d'Orsay, Paris. At about the time that Cézanne produced his *Bathers*, Bouguereau created this mythological work, a theme dear to the Salon.

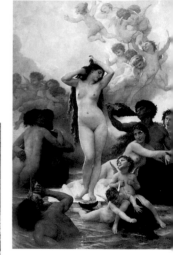

■ "To me it's marvellous, monumental", Moore said. "It's only about a foot square, but for me, it has all the monumentality of the bigger ones of Cézanne.... Perhaps another reason why I fell for it is that the type of woman he portrays is the same kind as I like."

BACKGROUND

1874: "The first impression"

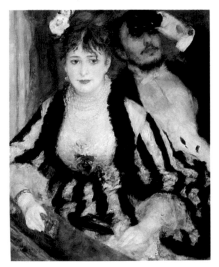

■ Pierre-Auguste Renoir, *The Balcony*, 1874, Courtauld Institute Galleries, London. This painting was sold for the modest sum of 425 francs, vital however because Pierre-Auguste desperately needed to pay the rent. His brother posed for the picture with a new model, Nini.

O n April 15, 1874, in the rooms of an old studio in the Boulevard des Capucines provided by the photographer Nadar, an exhibition of work by young emerging artists opened, with a total of 163 works. Among the other artists were Edgar Degas, Berthe Morisot, Claude Monet, Camille Pissarro, Pierre-Auguste Renoir, and Alfred Sisley. These and other artists had formed a cooperative the year before, modelled on the statute of a union of basket makers that Camille Pissarro had studied at Pontoise. The definition was simple: *Société anonyme des artistes, peintres, sculpteurs, graveurs*. At the 1874 exhibition, the group was nicknamed "Impressionists", a term they rejected however, because it was coined by the art critic Leroy, who used it intending to ridicule their new, disturbing pictorial language. The exhibition lasted a month and in Paris the joke went around that the painting method consisted of loading up a gun with various tubes of paint, and then shooting at the canvas, finishing off with a signature. The critics were harsh in their judgments and refused to take the exhibition seriously.

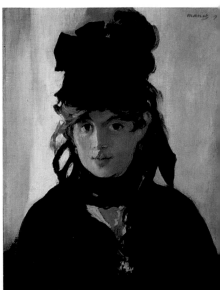

■ Edouard Manet, *Berthe Morisot with a Bunch of Violets*, 1873, Whitney Collection, New York. Berthe Morisot's old teacher, Guichard, commented that the entire Impressionist exhibition looked like the product of a "cross-eyed mind".

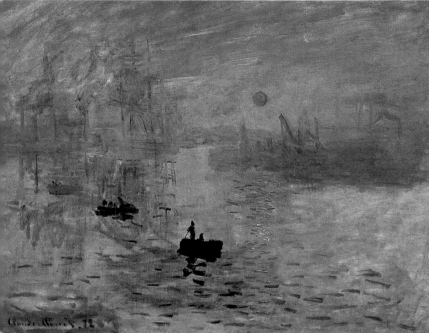

■ Claude Monet, *Impression: Sunrise*, 1872, Musée Marmottan, Paris. Monet wanted to give the name *Impression* to this view of Le Havre, with the sun gleaming through the vapours of the mist, and the masts of boats in the foreground.

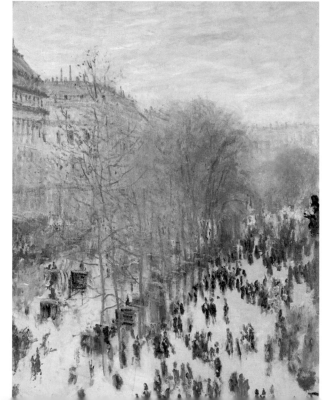

■ Claude Monet, *Boulevard des Capucines*, 1873, William Rockhill Nelson Gallery of Art, Kansas City. Joseph Vincent, landscape artist and Academy professor, commented: "So I look like them when I go walking in the Boulevard des Capucines? ... Hell and damnation!"

59

Portrait of Victor Chocquet

Painted in 1877, this portrait is now in the Columbus Museum of Art in Ohio. It shows Victor Chocquet, an employee at the Ministry of Finance in Paris, sitting at ease, in a comfortable chair, his rich collection of paintings visible over his shoulder. Cézanne painted various portraits of Chocquet, always with a hallucinatory quality about them, and numerous drawings.

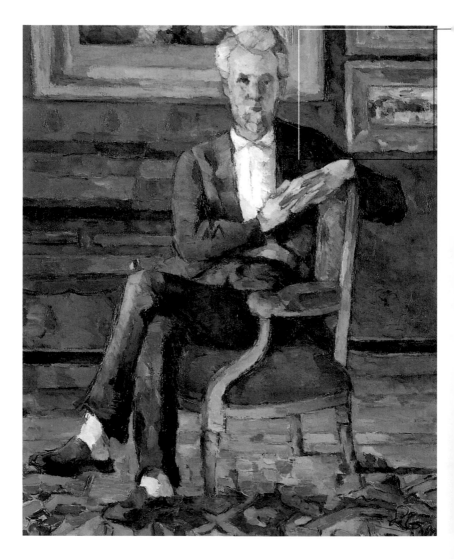

■ Chocquet had the spirit of the authentic collector who prefers to make his own discoveries, guided only by his own taste and pleasure. He shared with Cézanne a love for Delacroix. Over time he succeeded in acquiring a good collection of his works.

■ Pierre-Auguste Renoir, *Victor Chocquet*, 1875, Stiftung Oskar Reinhart, Winterthur. In a luminous range of bright colors, enriched by the *japonisme* of the upholstery, Victor Chocquet's face emerges, showing great psychological depth. Renoir was close to Chocquet because of his sincerity and warmth and painted two portraits of him, as well as one of his wife who posed by a wall with a painting by Delacroix.

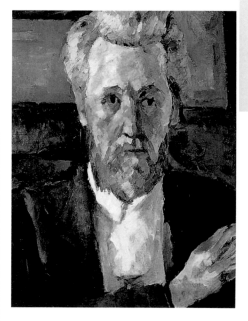

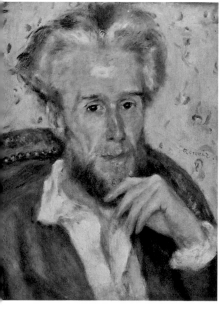

■ Cézanne, *Victor Chocquet*, 1877, Paul Mellon Collection, Upperville (Virginia). In this portrait, produced in the same year as the one now in Columbus, Ohio, Cézanne used the same technique: little blocks of pigment in a structure in which the face and space combine. Renoir introduced Cézanne to Chocquet who bought a painting and declared, "How well that will go between a Delacroix and a Courbet!"

The cafés and modern life

After 1866, the Café Guerbois, at 11 rue de Batignolles became the regular meeting place for painters, writers, and intellectuals interested in new currents of thinking. Cézanne, like Pissarro, went there intermittently when visiting Paris from the south. Every Thursday, meetings were held there but at any time of day groups of artists could be found engaged in vigorous debate. Years later Claude Monet recalled those meetings: "Nothing could have been more interesting ... we kept alert, we were encouraged in sincere, objective study, it kept us full of enthusiasm which, for weeks and weeks, kept us going until an idea was realized. People emerged strengthened, their purpose firm, their thinking sharper and clearer". The artists were immersed in a magnificent and sumptuous *ville lumière*, a city "full of dreams" come true: the solid buildings, the stations for transport, the great edifices for learning, treatment, recreation. The teeming life of *fin de siècle* Paris was for many artists (but never Cézanne) a recurring theme in their pictures.

■ Edgar Degas, *The Café de la Nouvelle-Athènes*, 1878. Less noisy than the Guerbois, the Nouvelle-Athènes in place Pigalle was famous for its ceiling, on which was painted an enormous dead rat .

■ Gustave Caillebotte, *Place d'Europe on a Rainy Day*, 1877, The Art Institute of Chicago. This is an immediately lively and effective picture of the city, seen from a particular angle on the wet street, the people on the right and the passers-by further back shown at the same moment.

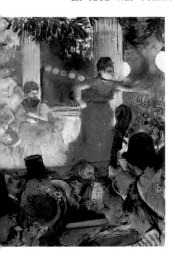

■ Edgar Degas, *Le café-concert Les Ambassadeurs*, 1875–77, Musée des Beaux-Arts, Lyon. Degas often went to the café-concerts of the capital between Montmartre and the Champs-Elysées; they were the subject of numerous paintings.

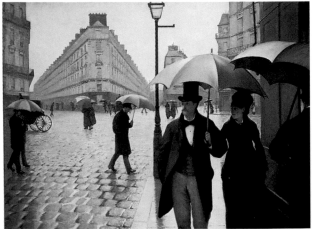

■ A drawing of the Café Guerbois by Manet from 1869, now in the Fogg Art Museum in Cambridge (Mass.). The Guerbois was a meeting place in the suburbs, with a garden and an arbour. It was not a smart place but many artists lived in the area.

■ Edouard Manet, *At the Café*. Manet was the intellectual leader of the group. At meetings Cézanne liked to show off his rough ways, almost as though challenging the elegant manners of the others.

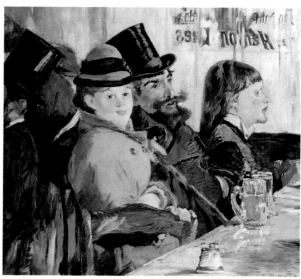

■ Henri de Toulouse-Lautrec, *L' Almée*, panel for the booth at La Goulue, 1895, Musée d'Orsay, Paris. The realistic characterization of the faces is achieved here with a great fluency of line in the construction, both in the figures and in the surroundings.

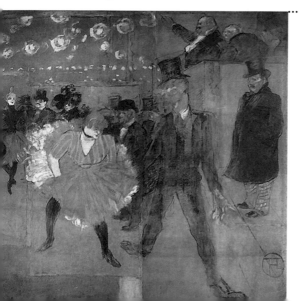

The nighttime Paris of Henri de Toulouse-Lautrec

Henri de Toulouse-Lautrec came from a family of ancient nobility and from infancy he drew as a hobby. He was a lucid witness to the teeming world of the metropolis, from cabaret shows to the brothels of Montmartre, the artists' quarter and art galleries. A draughtsman of great talent, he often painted Paris nightlife, showing the splendors, the misery, and the ambiguities in passionate pictures of actresses, dancers, scoundrels, and gentlemen in search of adventure.

MASTERPIECES

Madame Cézanne in a Red Armchair

Hortense Fiquet was one of Cézanne's favorite models and he painted her in a number of portraits. This is without doubt among his most emblematic portraits. Painted in 1877, it is now in the Museum of Fine Arts in Boston.

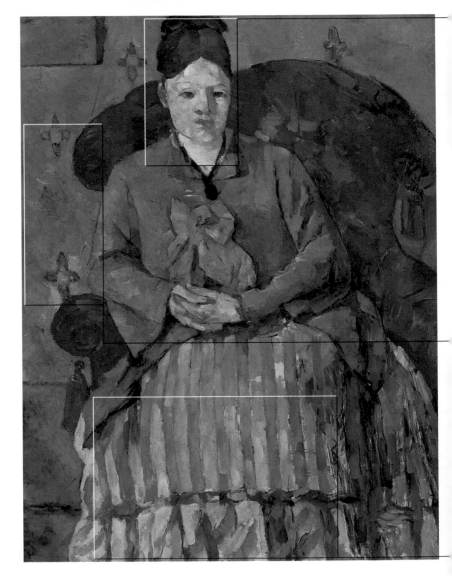

■ Hortense is shown here with a thoughtful expression: the eyes, rendered with little dabs, shine and stand out in the magnificent oval face. Hortense posed patiently for her husband, who needed an average of 150 sittings to complete a portrait.

■ Color is the force moving the entire work. The ochre of the wallpaper is lit by touches of blue, giving rhythm to the composition. Cézanne was especially attracted by the changing play of colors in the background, but also in the face and in the materials.

■ Pablo Picasso, *Seated Woman*, 1909, Private Collection. Picasso saw numerous works by Cézanne when he visited the collector Vollard in Paris, and he was enchanted by them. In the angle of the arms and in the hairstyle, this portrait perhaps shows something of Hortense.

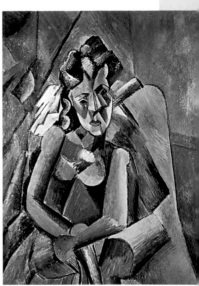

■ Using the horizontal lines of the dress, which contrast with the green band high on the wall and with the red of the armchair, Cézanne created an architectonic structure that rejected depth of field and created a strange unifying of planes.

The last appearance with the Impressionists

In the early part of April 1877, the Impressionists organized an exhibition in an apartment in rue Le Peletier. Monet showed around 30 paintings and Cézanne, for whom one of the best rooms had been reserved, showed 17, among them a portrait of Victor Chocquet. More people were interested than at the previous exhibition and initially the reception seemed less mocking. The art critic Georges Rivière published a journal in defence of the painters for the duration of the public exhibition called "L'Impressioniste, Journal d'Art", writing most of the articles himself, assisted occasionally by Renoir. Rivière stated that the artists had adopted the name of "Impressionists" to make it clear that in their exhibition there would be no paintings on historical or biblical, oriental or generic themes. None of this prevented the public and critics from being sceptical. Even Zola reviewed the show, singling out the figure of Monet for praise and adding, oddly, "I would like to mention Cézanne after him, he is certainly the greatest colorist in the group".

■ Pierre-Auguste Renoir, *Dance at the Moulin de la Galette,* 1876, Musée d'Orsay, Paris. The luminosity, the sensuality, and feeling of pleasure at the Moulin, were revived by his son Jean, who made it the subject of a film.

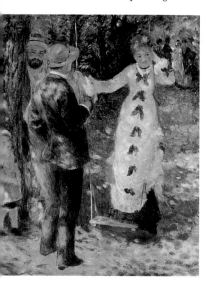

■ Pierre-Auguste Renoir, *The Swing*, 1876, Musée d'Orsay, Paris. This pretty scene is a free exercise in placing a figure in a landscape.

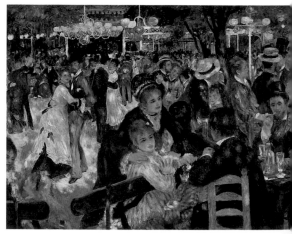

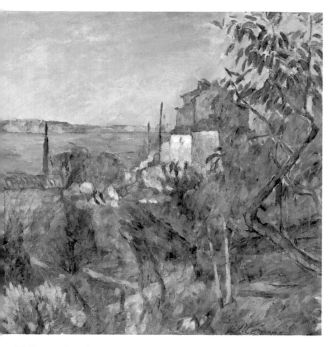

■ Cézanne, *The Sea at l'Estaque*, 1876, Rau Foundation for the Third World, Zurich. Even this painting, shown at the exhibition, did not evoke much interest and was defined as a maladroit work, or "strange". However, Rivière, Cézanne's staunch defender, underlined the eccentricity at the heart of Impressionist production: "It is of extraordinary greatness and inaudible calm; this scene goes past, it would seem, in the memory, leafing through one's life".

■ Cézanne, *Portrait of Victor Chocquet*, 1876–77, Private Collection, New York. Of all the works presented by Cézanne (oils and watercolors, for the most part landscapes and still lifes), this was the one that had the most disconcerting effect. Degas commented: "The portrait of a madman made by a madman". But the sarcasm does not overshadow the passion of this portrait, painted in small dabs: on the skin, on the beard, on the hair, greens, yellows, and reds mix together in every direction illuminating the physiognomy almost to the point of incandescence.

LIFE AND WORKS

Meeting Joris-Karl Huysmans

"**A** revelatory colorist… an artist with diseased retinas who, in his exasperated visual perceptions, discovered the first signs of a new art; so might we sum up this too-neglected painter, Cézanne". This is how the art critic and author Huysmans defined Cézanne, whom he met for the first time in Zola's house at Médan. Cézanne spent the summer there along with Paul Alexis, Numa Coste, and other intellectuals of the time. Huysmans was initially unenthusiastic about Cézanne's paintings, so much so that when he subsequently described the reviews of the Salons for the magazine *Le Voltaire*, he made no reference to Paul. It was Pissarro who entreated him to re-evaluate the artist, whom he had always supported and admired, and to take an interest in him. The writer praised Impressionist painting, declaring that with them "art has been turned upside down, freed from the slavery of the official institutions". However, at first he considered Cézanne's art to be too irresolute and at times "monstrous" to be of real interest. It is curious that at this time Huysmans always referred to the artist in the past (Cézanne was only 40), as though he considered him already consigned to history.

■ Photograph of Joris-Karl Huysmans. The interest of intellectuals and critics in art corresponded to the new shape of the market, no longer monopolized by the Academy or the Salons.

■ This photograph shows Emile Zola at work. It was thanks to Zola that Huysmans became an art critic for the journal *Le Voltaire*. His articles tended to unmask the false glories of the Salons and even offer acute observations on the Impressionists.

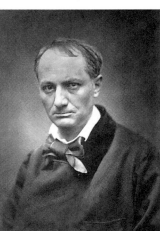

■ This photograph is of Charles Baudelaire, whom Cézanne admired. Baudelaire was not only a great poet, but also a great critic, and student of aesthetics, perhaps the greatest of his time.

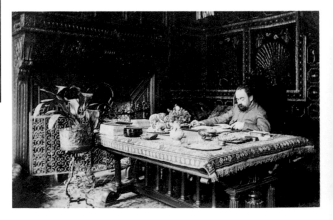

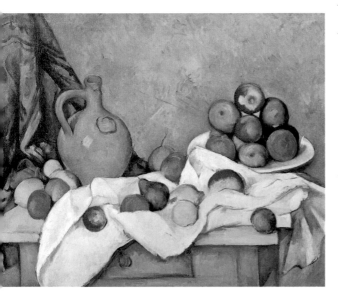

■ Cézanne, *Curtain, Jug, and Compotier*, 1893–94, Private Collection. On the subject of still life, Huysmans wrote: "And now hitherto absent truths can be glimpsed, tones as strange as they are real, patches of a singular authenticity".

■ Cézanne, *Château Médan*, 1879–81, Kunsthaus, Zurich. Later Huysmans began to appreciate the "sketched landscapes, attempts driven into limbo…, for the glory of the eyes, with the heat of Delacroix but without study or delicacy of hand".

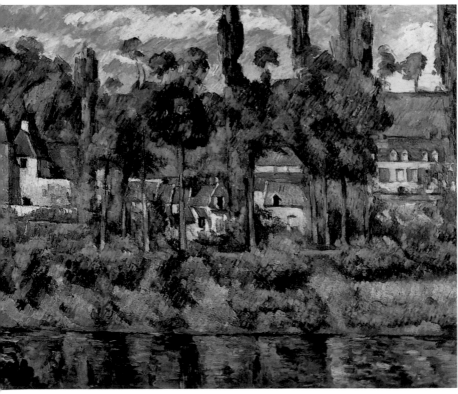

Still life

The writer Virginia Woolf called Cézanne's still lifes extremely simple, and yet highly complex. She regarded them as masterpieces. "What can six apples not be? There is a relationship between each of them, and the color and the volume. The longer you look at them the more the apples seem to become redder and rounder and greener and heavier … The pigment itself seems to challenge us, touch some nerve in us, it stimulates, excites … it arouses in us words that we didn't even know existed, it suggests forms where before we saw nothing but emptiness", she wrote. Her comments followed an exhibition in London organized by Roger Fry, which included 21 paintings by Cézanne. His still lifes were in fact far more than simple, direct representations of lifeless objects, the apples appearing to slide towards the spectator as though at any moment they might emerge from the painting.

■ Virginia Woolf is one of the most important writers of the 20th century characterized (like Cézanne) by an iron discipline with language, capable of reaching the fascinating balance between intellectual clarity, intensity of affections, and stylistic mastery.

■ Camille Pissarro, *Still Life with Pears in a Basket*, 1873, Scheuer Collection, Germany. It is likely that Pissarro was inspired by the still lifes of Cézanne but his own lifelong interest lay in painting *en plein air*.

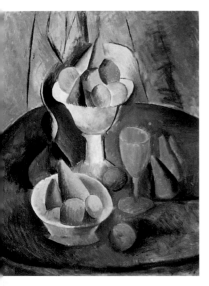

■ Pablo Picasso, *Bread and Compotier with Fruit on a Table*, 1908, Kunstmuseum, Zurich. To the new generation of painters, especially Picasso and Braque, Cézanne was a liberating force, the man who freed painting from convention.

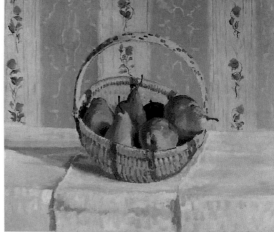

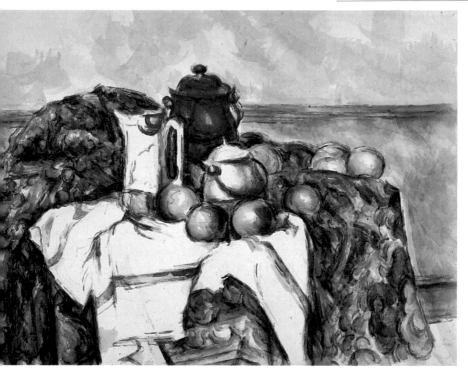

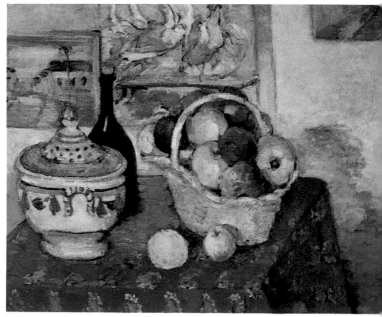

■ Cézanne, *Still Life with Blue Pot*, 1900–06, J. Paul Getty Museum, Malibu. In his later years Cézanne produced some still lifes in watercolor, which were exceptional for their size and luminosity. This is one of the most representative of his later style.

■ Cézanne, *Still Life with Soup Tureen*, c.1877, Musée d'Orsay, Paris. This was one of the first works in which Cézanne abandoned the atmospheric colors of Impressionism in order to bring out the intensity of "local" tone.

1870–1880

Biscuits and Fruit Bowl

This canvas, which dates from about 1877, was the prototype for many future still lifes. Cézanne would later use the same motifs – fruit, tables, and chairs – in more turbulent compositions. Today the picture is in a private collection in Japan.

■ The apples, the compotier, and the plate of biscuits are placed on a large cloth, rumpled and disturbed, which almost threatens to swallow up some of the apples and agitates the entire work. The brush-strokes are rigorous and faultless: precise, methodical and compact, imbuing the cloth with the dominant colors, the blue-violet and the yellow of the wallpaper.

■ The wallpaper with its olive-yellow background is patterned in wide diamond shapes with blue cross motifs at the four corners. This geometric structure, visible in other canvases, is used by Cézanne to give force and incisiveness to the composition.

■ Cézanne, *Still Life with Compotier*, 1880, Museum of Modern Art, New York. This still life, one of the artist's favorite subjects, belonged for a time to the painter Gauguin and was to be the "protagonist" of a picture by Maurice Denis of 1900, which was dedicated to Cézanne.

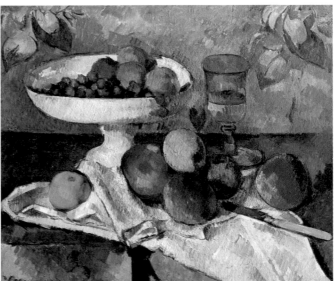

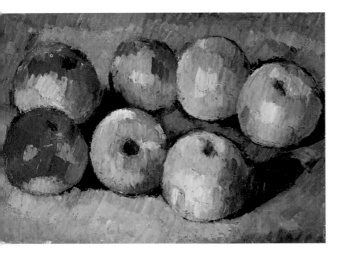

■ Cézanne, *Apples*, 1877–78, Fitzwilliam Museum, Cambridge. Apples make their first appearance around the 1870s. Missing in earlier still lifes, from this point on they become a recurring subject. The writer Huysmans exalted these "brutal apples, rough, constructed with a palette knife, shaped by the oscillation of the thumb" characterized by "furious impasto of vermilion, yellow, green, and blue".

BACKGROUND

Degas and the immediacy of photography

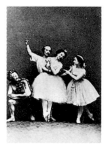

The first photographers tried to perfect techniques for reproducing natural colors, just as they hoped to resolve the problem of capturing moving objects. Daguerre, for instance, declared in 1844 that he was able to photograph galloping horses and birds in flight, but the technique that really made these results possible was only really established from 1870 onwards. Between 1870 and 1880 therefore, an extremely important leap occurred: it became possible to photograph rapidly moving objects, freezing them in poses that not only represented a challenge to convention, but also went beyond the visual possibilities of the unassisted eye. "Instantaneous" photography (that is, filming moving bodies) was frequently used by the painter Edgar Degas, who thus opened up a new way of depicting urban society. Like those of his Impressionist colleagues, Degas' letters maintain an ambiguous silence on the subject of photography. But the testimony of friends and colleagues confirms that he was extremely interested in photography and made great use of it. According to Paul Valéry, Degas was among the first painters to realize what photography could teach the artist.

■ André Disderi, *cartes-de-visite* of people dressed in costume for the ballet *Piero de' Medici*, c.1876.

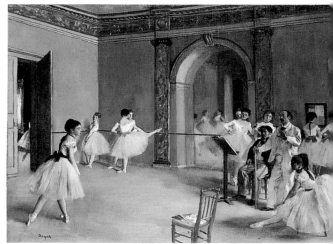

■ *Carte-de-visite* photograph of Edgar Degas, c.1862. Compared with Degas' self portrait you can see the same hairstyle and the same buttoning of the waistcoat.

■ Degas, *Self Portrait*, 1862. Degas may have painted this from a photograph or some faithful reproduction because the inversions common to self portraits by mirror are missing.

■ Cézanne, *Portrait of the Artist*, 1895, Private Collection. Cézanne also made great use of photography, which allowed him to overcome the problem of lengthy posing for self portraits. This is his only self portrait in watercolors. Cézanne regarded himself as ugly and unattractive, often rough and ordinary where Manet and Degas were elegant.

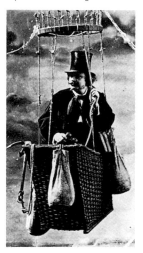

■ Instantaneous photography was an enormous help to caricaturists like Nadar and Gustave Doré, who used both camera and pencil together. The results were often closer to photography than traditional forms of caricature.

■ Edgar Degas, *Foyer de Danse à l'Opéra*, 1872, Musée d'Orsay, Paris. Degas loved analyzing the bodies of the girls in balletic poses.

A love-hate relationship between Degas and Cézanne

Unlike Paul Cézanne, Degas, descended from an aristocratic Breton family, was a man of the world, actively involved with the Impressionists, and a member of urbane Parisian society. Between the two a polite contempt soon emerged, which led to each ignoring the work of the other. It wasn't until 1895 that Degas "discovered" Cézanne, the occasion was a one-man show organized by Ambroise Vollard.

BACKGROUND

New sensations

\mathbf{W}hy did Cézanne continually return to the same subjects: portraits, still lifes, landscapes? Perhaps these subjects in particular were not at the heart of it, but rather, he wanted to get away from simple imitation of nature. The figurative results may seem incongruous, but his was a mental vision, "pure" painting. It was thanks to Cézanne, in a number of ways, that art gradually became more conceptual. It was probably no accident that in the early 1880s a writer like Huysmans should start work on his new novel *À Rebours* (*Against Nature*), a treasure trove of dreams and allusions. The poet Charles Baudelaire, attempting to aim at pure poetry, described the "temple of nature" as a "forest of symbols" and correspondences. Many aspiring painters set out to look for new dimensions, travelling in search of realities distanced from their own time and space. In these closing decades of the century, the artist concentrated increasingly on the language of painting which, through relationships between colors, volumes, and the various parts of the composition, sought to achieve a solid, unchanging order, free from the deception of optical vision.

■ Odilon Redon, *With Closed Eyes*, 1890, Musée d'Orsay, Paris. For a long time Redon, who was more or less contemporary with the Impressionists, remained in complete isolation as a result of his mysterious and unsettling art, unrelated as it was to Impressionism or state-sanctioned art.

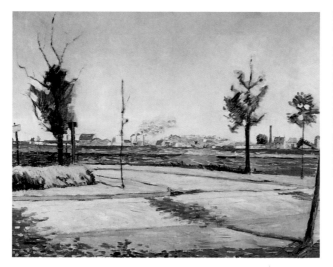

■ Paul Signac, *The Road at Gennevilliers*, 1883, Musée d'Orsay, Paris. On June 9, 1884, Signac and a group of other artists founded the Société des Indépendants, a permanent institution formed to suppress abuses of power by the Salon jury, and intent on putting all artists freely on show.

■ Paul Signac, *The Seine at Herblay*, 1889, Musée d'Orsay, Paris. Between Seurat and Signac a firm friendship sprang up. Both shared Chevreul's ideas on the behavior of color in visual perception, and both sought chromatic harmony. Pissarro was inspired by the theories of the two young artists which finally allowed him to channel his sensations.

■ Georges Seurat, *Sunday at the Grande-Jatte*, 1884–86, The Art Institute of Chicago. Seurat eliminated the superfluous, insisting on color and on geometrical structure, without yielding to the fascination of the perceptions.

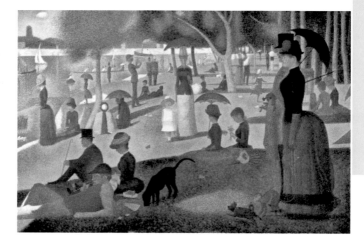

■ Massimo Campigli, *Homage to Seurat*. Campigli produced this homage as evidence of his French training.

Pointillism

In his book *On the Law of Simultaneous Contrast of Colors*, published in 1839, Eugène Chevreul stated that complementary colors, such as blue and orange or red and green, become more vivid and intensify in turns if juxtaposed, while if mixed they are neutralized. The value of color is therefore not an absolute but depends on the rapport with other colors. Pointillism, a painting technique developed by Seurat, consisted of juxtaposing on the canvas miniscule dabs of pure color that "recompose themselves" when viewed from a distance.

1880–1890

Self Portrait with Hat

This is one of Cézanne's most surprising self portraits. It is well known, having formed part of important collections and been shown in numerous exhibitions. Painted between 1879 and 1882, it is now on display in the Kunstmuseum, Bern.

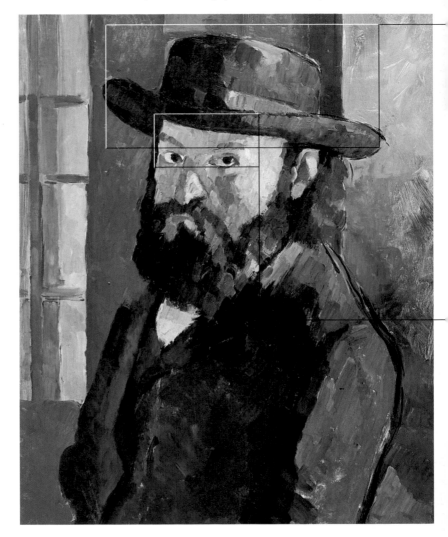

■ This detail is perhaps a reference to Cézanne senior's commercial career as a hatter in Aix. Combined with the beard, the hat confers on the entire self portrait an almost rabbinical feeling of austerity and severity, as though, in some way, Cézanne wanted to challenge the viewer.

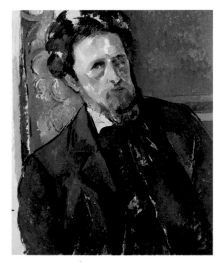

■ Cézanne, *Portrait of Joachim Gasquet*, 1896–97, Národní Galerie, Prague. Cézanne subsequently painted other portraits in which volume was increasingly simplified, pushing himself, as in this portrait of his friend Gasquet, towards daring examples of posture, completely off-balance in distorted perspective.

■ The gaze that Cézanne turns on himself is one of the most disconcerting of his entire oeuvre. Of his 46 self portraits, 26 were in oils and 20 on paper. The frequency of the subject seemed to be the result of his shyness, which made him incapable of working with professional models.

Difficulties with his father and marriage to Hortense

■ One of Paul Cézanne's last letters to his son Paul, dated July 29, 1906. The boy felt genuine affection for his father and was of great support to him in the last stages of his life.

After Paris, when Cézanne decided to move back to the south in order to enjoy the "most complete tranquillity", the conflict with his father gradually intensified. Louis-Auguste continued to criticize the passivity and the continual hesitations of his son. A strong and determined man himself, who had created a fortune from nothing, he could no longer tolerate Paul's denial, even when confronted with evidence of the existence of Hortense and Paul's son by her. To punish him, he decided to make him a minimal allowance, appropriate to a single man. Paul was forced to turn to Zola, who promised to help him out for as long as was necessary. It was only after the continued insistence of his mother, who took her son's side, that Louis-Auguste decided to help Paul and make him a monthly allowance to support the whole family. In his later years the banker, increasingly weak and in ill health, made a fair portion of his fortune available to his children. By now wearied, he reluctantly agreed to the marriage between his son and Hortense, of whom he did not have a very high opinion. The wedding took place on April 28, 1886 in Aix-en-Provence with the whole family present. Louis-Auguste died a few months later, on October 23 at the age of 88.

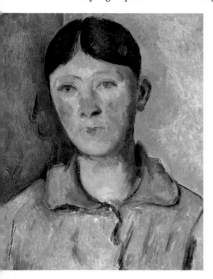

■ Cézanne, *Madame Cézanne*, 1888–90, Musée d'Orsay, Paris. It was Paul's sister Marie who brought about the reconciliation between father and son. She was aware of the existence of an illegitimate son and, although she was not fond of Hortense, as a good Catholic she believed marriage would bring Paul back to the true path.

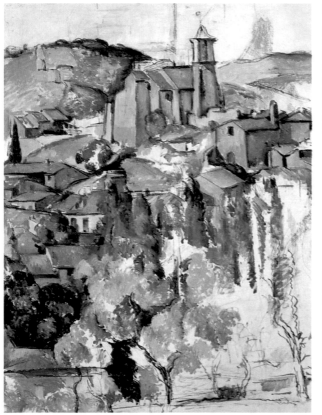

■ Cézanne, *Gardanne*, 1885–86, The Brooklyn Museum, New York. Situated 15 kilometers (9 miles) from Aix, this city, like l'Estaque, served as a refuge for Paul's family, rejected and shunned by his elderly father Louis-Auguste.

■ Cézanne, *Boy Resting*, c.1890, Armand Hammer Museum of Art and Cultural Center, Los Angeles. At the time of this portrait the young Paul was about 20 years old. Shy and reserved in character, like his mother, he patiently posed for his father from a young age.

■ In a letter to Zola in 1878 Cézanne said of his father: "He has heard from several people that I have a child and tries to take me by surprise in every way possible… I add nothing else… appearances deceive, you may take me at my word".

Chestnuts and Farm at the Jas de Bouffan

The tree-lined driveway behind the Jas de Bouffan was enclosed in a circle of chestnut trees. Painted between 1885 and 1887 at the family home, this picture is now in the Pushkin Museum, Moscow, and is one of the most mature examples of a landscape.

■ Cézanne, *Chestnut Trees at the Jas de Bouffan*, 1885–86, The Minneapolis Institute of Art. As in Muslim art, we find "ornamental and complicated lines, evanescent, in filigree" (Meyer Schapiro) which permit a glimpse of the outline of Mont Sainte-Victoire in the background, a site so dearly loved by the artist.

■ The oil paint is spread on in layers, waves that do not seem to follow any pattern. The brushstrokes are so quick they make it clear that the artist has now perfectly mastered his tools and is using color with an audacity that just a short time ago one could not have imagined he possessed.

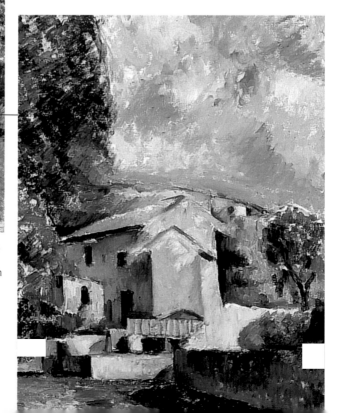

■ The geometry of the buildings of the Jas de Bouffan is seen through "the side wings" of the trees which, following the line of the wall, lead the eye to the farmhouse in the background.

The break with Emile Zola

Claude Lantier was a painter who, lacking creative power, was unable to realize his dreams and ambitions, was reduced to bankruptcy and then to suicide, subjugated by the chaos of genius and madness that had taken hold of his mind. This is the plot of the novel that Emile Zola published in 1886 with the title *L'Oeuvre*, in which boyhood memories were revived, his friendship with the Impressionists, the Salons, the first experiments *en plein air*, and a dense web of autobiographical details confirming Zola's intention of using contemporaries and friends as inspiration. Cézanne read the novel and painfully perceived that Zola intended Claude Lantier to be a portrait of himself. The painter, despite his shabby and unassuming appearance, had in reality great refinement of thought and spirit and could not fail to understand that the friendship was ending. The "aborted genius", as Zola described Lantier-Cézanne, responded with a cordial but cool letter: "I thank the author of the *Rougon-Macquart* for this kind token of remembrance, and I ask him to permit me to clasp his hand while dreaming of years gone by. Paul Cézanne". The two men never met again.

■ Theophile Silvestre supplied a physical description of the Emile Zola, pictured below, as short, robust in body, and very energetic.

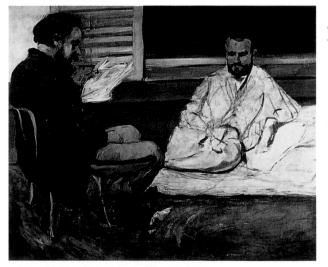

■ Cézanne, *Paul Alexis Reading to Zola*, c.1869, Museu de Arte, São Paulo. After the break between Cézanne and Zola, Vollard went to see Zola, who clearly expressed his opinion of his friend: a talented individual without willpower.

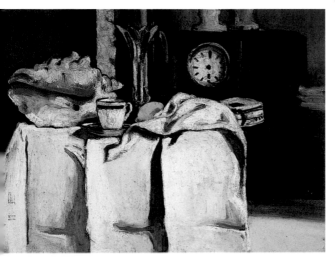

■ Cézanne, *The Black Clock*, c.1870, Private Collection. The picture of the clock without hands was one of many works by the artist that Zola possessed. He kept them however "under triple lock" in the attic at Médan "away from evil eyes".

Zola as art critic

Emile Zola worked for the publishers Hachette, where he met the critic Duranty, and began to write literary reviews for the paper "L'Evènement" and then in 1866 art criticism. It was soon clear that he had a sharp attitude both towards the Salon jury, whom he denounced as lacking in principles, and the official artists, champions of an art which was merely "an amputated corpse". He followed the Impressionists in particular because he sought new expressive forms. He never seems to have grasped the real motives of Cézanne, however: "He had the spark. But if he had the genius of a great painter, he lacked the willpower to become one".

■ Cézanne, *House with Red Roof*, 1887–90, Private Collection. For some years Cézanne had lived in the south, preferring a detached life, utterly different from (and not easy to reconcile with) the worldliness and luxury to which Zola and his wife were accustomed.

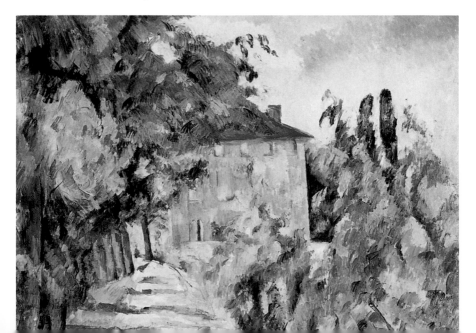

Harlequin

In about 1888, Cézanne, having concentrated on still lifes, landscapes, and portraits for more than 20 years, returned to painting figures in movement with this Harlequin. The work is now in the National Gallery of Art in Washington.

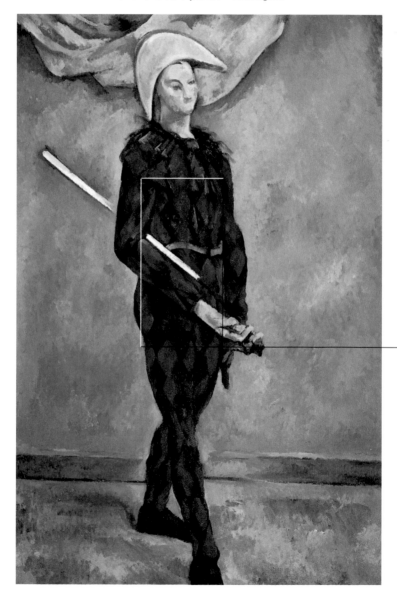

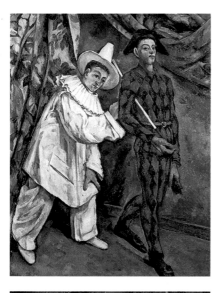

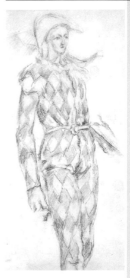

■ Cézanne, *Mardi Gras*, 1888, Pushkin Museum, Moscow. Cézanne was fascinated by figures from the Commedia dell'Arte. Here he depicts his son Paul in Harlequin costume and his friend Louis Guillaume as Pierrot.

■ Cézanne, *Harlequin*, c.1888, The Art Institute of Chicago. This is one of Cézanne's most complex figure drawings. It may have been modelled on a puppet or a mannequin.

■ The technical virtuosity of the drawing can be seen in the diamond-patterned costume in bright, fiery red, which contrasts with the white baton. It is one of his strangest pictures and was to have the most striking effect on new generations of artists.

■ Cézanne, *Studies for Mardi Gras*, Département des Arts Graphiques, Musée du Louvre, Paris. These are drawings of his son Paul: the mobility of expression and the intensity of gaze were to dissolve in the painting of Harlequin.

Symbolist painters

■ Emile Bernard, *Still Life with Jug and Apples*, 1887, Musée d'Orsay, Paris. Like Gauguin, Bernard had a sinuous and decorative way with lines (he was also in fact a very able designer of textiles and glass), unlike the violent contrasts which characterized the work of Vincent van Gogh at about the same time.

During the 1880s and 1890s, Impressionist naturalism reached a crisis point. Artists and public alike felt the need to react to growing positivist materialism with a formal expression that tried to recover the romantic leanings of the early 19th century. Symbolism sought a synthesis among all methods of artistic expression, from painting to poetry, from music to literature. Even though these new studies involved the whole of Europe, the leading role once again fell to France where the aesthetic debate spread to magazines, to literary and philosophical texts, and to groups of artists. The figurehead of the movement in painting was Gauguin, who, according to Maurice Denis, was to artists in 1890 what Manet had been in 1870. Seeking seclusion and a more primitive subject matter, Gauguin established a base at Pont-Aven in southern Brittany. In the raw purity of the Breton environment, he encouraged his followers to paint not from real life but from memory. The result was an essential ideal that took shape through the careful study of form and color. Color became the means by which a symbolic value was conferred on images.

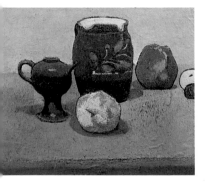

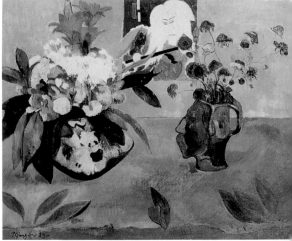

■ Paul Gauguin, *Still Life with Japanese print*, Museum of Modern Art, Teheran.

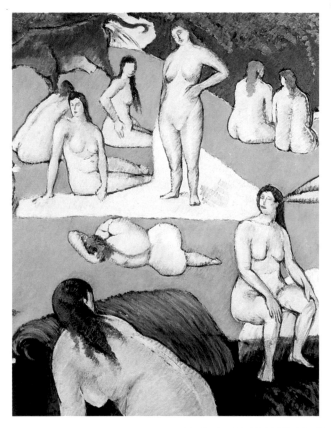

■ Emile Bernard, *Bathers with Red Cow*, 1889, Musée d'Orsay, Paris. Together with Louis Anquetin, Emile Bernard developed a style of art known as Cloisonnism in which pure colors were placed close together and articulated by clearly defined contours. The technique is particularly associated with the Pont-Aven School.

■ Paul Gauguin, *Breton Calvary: The Green Christ*, 1889, Musées Royaux des Beaux-Arts, Brussels. Gauguin modelled this painting on a stone Pietà next to the church at Nizon in Pont-Aven, relocating it the coast of Le Pouldu.

Exoticism and primitivism

In the course of the 19th century the massive European colonial expansion reached a peak. After Japan, it was the turn of Asia, Africa, and America. Fashions like *japonisme* were indicative of Europe's encounter with other cultures. At the same time artists sought their own ancient roots, their origins, by retreating into their own artistic cultures. In this way exoticism and primitivism were born. They were not only questions of taste but, as with Gauguin, brought about a search for a "lost paradise", unifying art and life.

The experience of Renoir

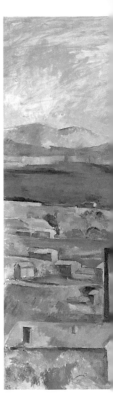

Cézanne and Renoir became friends in 1863, but it was later, as older men, that the bond between them was strengthened. Returning from a trip to Italy, Renoir visited Marseille and, struck by the landscape, decided to stay on longer in order to paint *en plein air*. His earlier certainties, those of his youth, were increasingly being questioned, and he admired the isolation of Cézanne and like him wanted to paint in a more solid style. He sensed he still had a great deal to learn and started producing landscapes, which for him had unusual asperity: the brushstrokes became more constructive and less of a simple "impression". He too began to feel the crisis of Impressionism, and in a letter to Vollard he declared that he no longer knew how to paint or draw. This was why he had gone to Italy, to re-learn: "In Paris you have to be content with little…. Raphael, who did not work outdoors, had however studied the sun, because his frescoes are full of it. By looking at the exterior I have ended up not paying attention to the little details that extinguish the sun instead of exalting it". In an unchanging setting, drenched in sunlight, Renoir created more imposing and constructed canvases.

■ Cézanne, *Mont Sainte-Victoire*, 1888–89, Museum of Art, Baltimore. The mountain was Cézanne's "little sensation" and he painted it "from the inside" so that volumes emerge.

■ Pierre-Auguste Renoir, *Self Portrait*, 1889, Sterling and Francine Clark Art Institute, Williamstown.

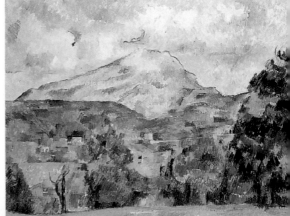

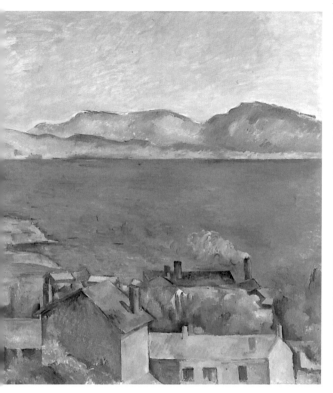

■ Cézanne, *The Bay of Marseille seen from l'Estaque*, 1886, The Art Institute of Chicago. For Renoir the contact with Cézanne was definitive. Perhaps he would have shared the view of Meyer Schapiro on these works, that they exuded: "A marvellously tranquil force… the deep sensation of the Mediterranean".

■ Pierre-Auguste Renoir, *Mont Sainte-Victoire*, Yale University Art Gallery, New Haven. Compared with Cézanne, Renoir was sensitive to an "external" vision as can be seen in the effects of the atmospheric light and the surfaces of objects.

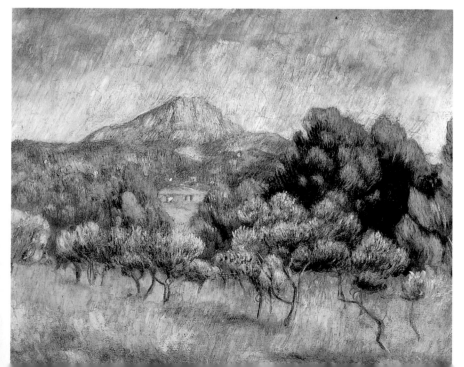

The Universal Exhibitions

Progress in the fields of engineering and architecture could be followed through the Universal Exhibitions that took place in Europe in the second half of the 19th century. They were recurring celebratory events, held on symbolically important dates, which turned into occasions when attention could be devoted to the interweaving of technology and science, architecture, and art. The exhibitions were devised to disseminate new ideas in all fields. In fact the real protagonist was architecture: iron and glass were the new materials used, which cut down on building time and meant that structures could be re-used.

The temporary nature of the Exhibition buildings and their siting in urban city centers were common to all exhibitions. The public flocked to these events, obliging the organizers to create increasingly functional infrastructures such as hotels, railways, and underground trains, and to improve internal services. However, the increase in workload and costs quickly showed the advantage of museums over exhibitions.

■ Henri Gervex, *The Debate of the Jury*, presented at the Paris Exhibition of 1889. By the end of the 19th century, aspiring to the new and modern began to bring about a new aesthetic throughout Europe, which saw formal qualities even in industrial products.

■ Palais de l'Exposition Universelle in Vienna, 1873. The layout of the exhibition in Vienna broke with the tradition of using a single building. It used different pavilions spread over increasingly large surface areas.

■ The building of the Eiffel Tower for the Exposition Universelle in 1889 commemorated the first centenary of the storming of the Bastille. The tower is made entirely of iron and dominates the capital.

■ The first Great Exhibition in America was held in New York in 1853. This etching shows the Machinery Building at the 1876 International Exhibition in Philadelphia.

■ View of the Universal Exhibition of 1867 at the Champ de Mars in Paris, Private Collection. The French exhibitions placed more emphasis on the arts than those held in other countries.

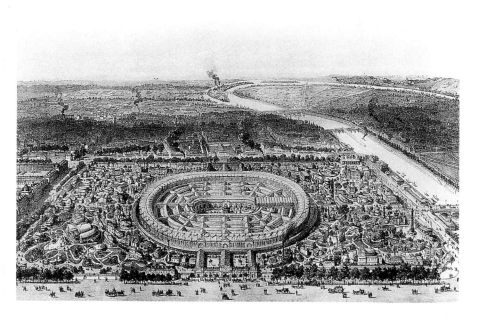

1880–1890

Kitchen Table

Painted in about 1889, this canvas is now in the Musée d'Orsay in Paris. It is one of the few signed by Cézanne, in blue at the bottom right-hand corner, and is one of the richest in terms of figurative elements arranged in space.

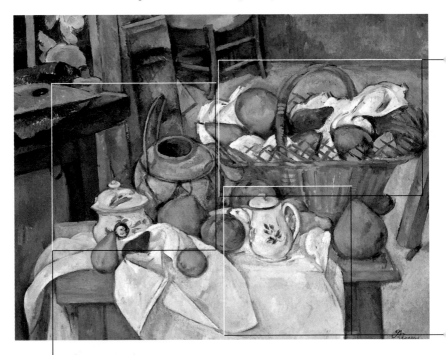

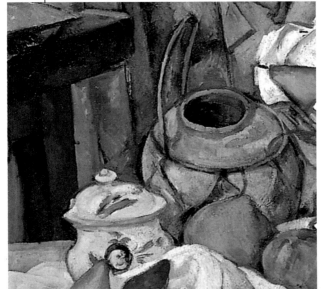

■ The blue-purple ginger jar with its string holder is an object that Cézanne used frequently. When Joachim Gasquet saw this still life in the artist's studio, he mistook the willow strands for decoration. Other familiar elements are the sugar bowl, the "tablecloth of fresh snow", the apples, and pears.

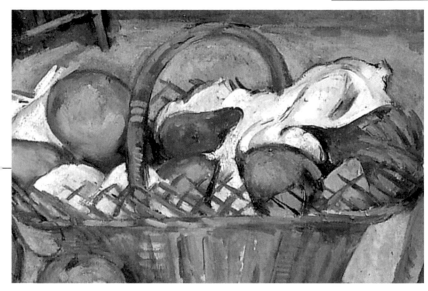

■ Nothing is left to chance in the placing of the objects, arranged at different angles, like this large wicker basket containing seven pears. It appears to lean out from the back right corner of the table.

■ Pablo Picasso, *Bread and Compotier with Fruit on a Table*, 1908, Kunstmuseum, Basel. Picasso paid tribute to the "disquiet" of Cézanne, to whom he owed a great deal in his early career.

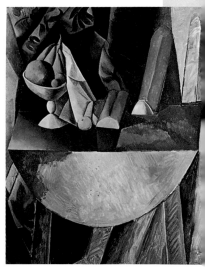

■ Cézanne rejected traditional unitary perspective and maintained a multiplicity of viewpoints. This jug is not seen from the same viewing point as the objects around it.

The rise of capitalism and images of socialism

From the second half of the 19th century, modern industrial capitalism – albeit in different forms – was established in countries such as Britain, France, Germany, Russia, the United States, and Japan. Particularly in the 1880s and 1890s, capitalism could avail itself of new sources of energy such as electricity, new raw materials such as petroleum, and new techniques derived from progress in scientific research. Agricultural improvements – through the use of machines and fertilisers – and advances in medicine – especially in disease prevention – resulted in population growth, which itself increased the availability of a workforce for industrial production. Capitalist expansion and the concentration of production facilities, created on the one hand an increasingly prosperous middle class, and on the other noticeably increased the mass of the industrial proletariat. Throughout Europe, after the Paris Commune and the collapse of the First International in 1876, the position of the socialist parties became increasingly significant.

■ Claude Monet, *The Garden at Saint-Andresse*, 1867, The Metropolitan Museum of Art, New York. Many writers analyzed the crisis of the haute bourgeoisie and the aristocracy, who up to that point had imposed their own style and values on 19th-century society.

■ Honoré Daumier, *The Washerwoman*, 1863, Musée du Louvre, Paris. The subject matter shows Daumier's need to depict the present.

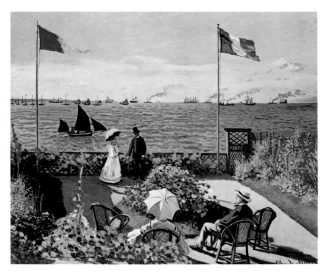

■ Constantin Meunier, *Removal of a Broken Crucible, Glass Factory at Val Saint-Lambert,* c.1884, Musée Constantin Meunier, Musées Royaux des Beaux-Arts de Belgique, Brussels. In this work, Meunier glorifies manual labor in his treatment of a scene previously considered "vulgar".

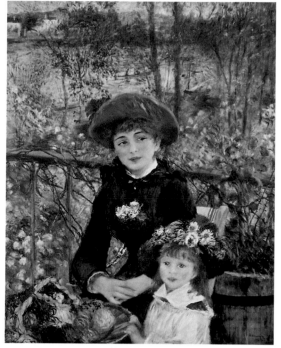

■ Pierre-Auguste Renoir, *On the Terrace,* 1881, The Art Institute of Chicago. This picture was painted on the Fournaise restaurant terrace at Chatou; the model was the actress Jeanne Darland, of the Comédie Française.

■ Robert Koeler, *The Socialist,* Kunsthistorisches Museum, Berlin. Despite internal contradictions, the socialist parties experienced tumultuous growth and their organization grew in strength and influence.

The Blue Vase

Painted between 1889 and 1890, this painting is now in the Musée d'Orsay in Paris. It is among Cézanne's most original still lifes and is also one of the most well known.

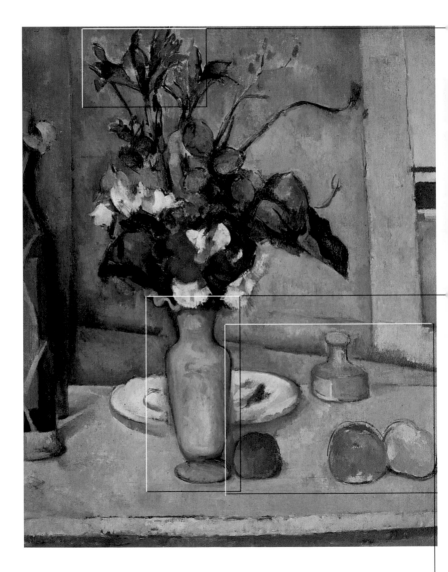

■ Not easily identified, the bunch of flowers seems to consist of deep purple irises surrounded by small yellow flowers, cyclamen, and geraniums. Unlike many of his colleagues, Cézanne never showed great interest in painting flowers.

■ The blue vase, silhouetted against the white plate, seems to be lit by a beam coming from the viewer's direction. It almost blends in with the blue of the wall. Because of this frontal light, the effect becomes intense, almost ghostly.

■ Henri Matisse, *The Blue Window*, 1913, Museum of Modern Art, New York. Years later the almost shadow-free objects in Cézanne's work inspired Matisse to produce this picture, created in a moment of particular spirituality and mysticism.

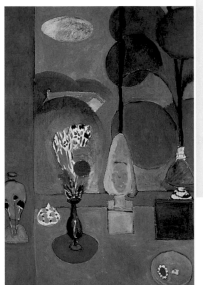

■ Although Cézanne arranges the objects with meticulous care, it is not the objects themselves that he is interested in. His fascination is with form, shape, and color, and the relationship between the various elements.

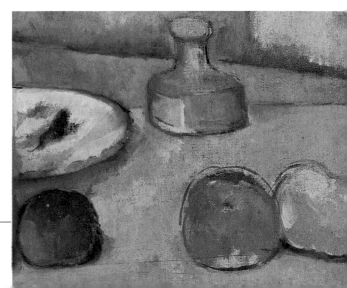

A final flowering: the Bathers

■ Cézanne, *Bellona* (after Rubens), 1879–82, Private Collection. Cézanne had always been struck by this ability to render the twisting of the body with the raised arm, a particularly expressive pose, strong and full of dignity.

Throughout his life Cézanne sketched male nudes in his notebooks, but it wasn't until later life that his approach to depicting the human body reached full maturity. In pictures on the subject it is clear that the artist wanted to keep fresh in the memory his academic studies and the work of the ancient masters, their sculptures, and their models. Copying Classical sculptures was a fundamental training for the painter, much more so than life drawing, which however, Cézanne was to set aside fairly quickly. In his treatment of male bathers, more so than with female bathers, the compositions remain fairly constant; the male subjects appear more conventional and distant, even if at this stage Cézanne was trying to give greater depth to the surrounding space and more mobility to the figures. The subject matter was perhaps suggested by memories of the time when Paul and his friend Zola used to spend their summer holidays swimming and relaxing in the beautiful countryside of Provence.

■ Cézanne, *Bather and Rocks*, c.1867–69, The Chrysler Museum, Norfolk (Virginia).

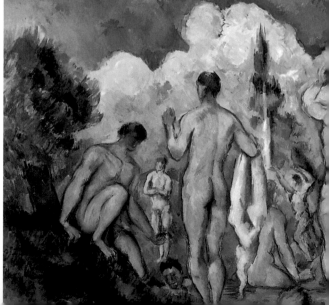

■ Cézanne, *The Large Bather*, c.1885, Museum of Modern Art, New York. With this picture the artist overturned tradition, creating an absorbed expression in the face and the eyes, so that the bather appears totally wrapped up in his own thoughts.

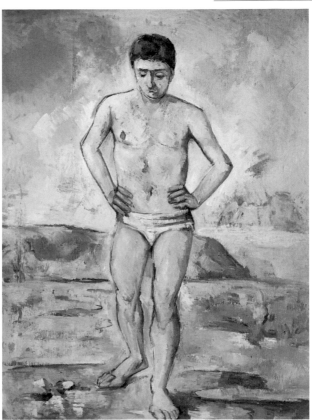

■ Cézanne, *Bathers*, c.1890, Musée d'Orsay, Paris. Set in an almost timeless dimension, this is one of his most emblematic canvases, in which the bathers interact with great mobility – the young man on the right, full of vitality, is responding to the man who is waving his arms on the other side of the bank.

■ Pablo Picasso, *Acrobat and Young Tumbler*, 1905, Pushkin Museum, Moscow. Cézanne's exhortation to treat nature "according to the cylinder, the sphere, the cone" has already borne fruit in this work, in the solid, almost stonelike carved figures.

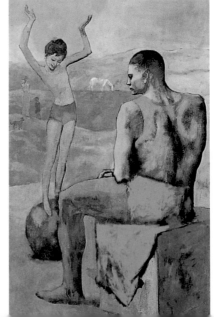

103

The cone, the cylinder, and the sphere

The first one-man show

■ Cézanne, *Portrait of the Artist*, 1878–80, Phillips Collection, Washington. This canvas was part of Vollard's enormous collection: the dealer had excellent business sense and from the very beginning preferred work by young artists at low prices. Vollard was in no hurry to sell and did not hesitate to reinvest capital immediately.

After the death of Père Tanguy in 1894, all his property was sold at auction, including six paintings by Cézanne. Tanguy had been Cézanne's only dealer and Pissarro decided to introduce the young Ambroise Vollard to his friend Paul. Vollard had a gallery in rue Laffitte, where the majority of Parisian galleries were sited. He lacked confidence in his own taste, but he listened to advice and had the sense to follow the wise counsel of Pissarro and Degas. For 20 years Cézanne had been living a reclusive life, absent from Paris exhibitions and Pissarro encouraged Vollard to get in touch with him. Cézanne sent him 150 pictures and the one-man exhibition opened in the autumn of 1895. Former painting colleagues and avant-garde artists, unlike the critics, hailed him as a master. As Pissarro wrote: "The only ones who do not feel this fascination are precisely those artists and dealers who, by their mistakes, have amply demonstrated an absence of sensitivity. As Renoir very rightly said, these paintings have a *je ne sais quoi* similar to things from Pompeii, so threadbare and so marvellous!".

■ Maurice Denis, *Homage to Cézanne*, 1900, Musée d'Orsay, Paris. This painting moved Cézanne immensely. The meaning is clear: the increasing numbers of followers who saw in him the advent of a new era in art compensated for the absence of official recognition.

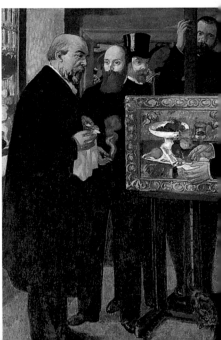

■ Cézanne, *Four Bathers*, 1879–82, Museum Boymans-van Beuningen, Rotterdam. Vollard used this drawing to illustrate the invitation to one of his Cézanne exhibitions. He later organized a series of important exhibitions for van Gogh, Picasso, Matisse, Gauguin, and others.

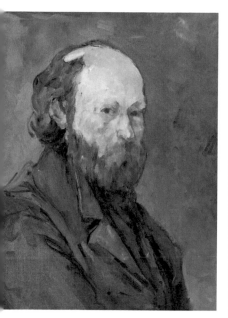

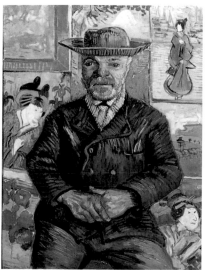

■ Vincent van Gogh, *Portrait of Père Tanguy*, 1887–88, Private Collection. The legendary Tanguy started out as a paint trader and protector of artists. He was very taken with Cézanne and became his dealer.

■ Pablo Picasso, *Portrait of Vollard*, 1915, Pushkin Museum, Moscow. Like Cézanne (see pp. 122–123) and others, Picasso painted Vollard in sombre mood, with his forehead prominent and his gaze downcast. Vollard organized the first exhibition of the young Picasso in 1901.

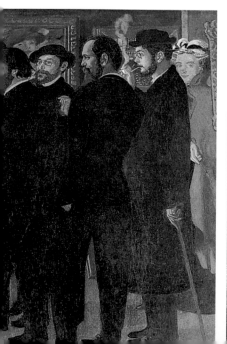

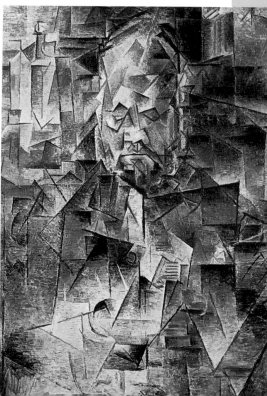

The Orient and the ancient

In the closing decades of the 19th century, oriental art began to appear in Europe and was a source of inspiration to many artists who, thanks to the Universal Exhibition of 1867, had come into contact with Japanese art. The fashion for *japonisme* spread throughout France. Items began to appear in the *ateliers* where artists collected porcelain, prints, costumes, and kimonos, which appeared as details or often as key features in their paintings. Underlying this interest was not fashion as such but an exact formal study that inspired original viewpoints and compositions; the absence of western perspective favored flat, decorative surfaces with overlapping figures and objects. Cézanne was not greatly attracted by oriental art, which found no echoes in his imagination. And Renoir, who preferred to study the oriental subjects of Delacroix, was the same. Georges Rivière defined Cézanne as a "Greek of the golden age" emphasizing in his biographical notes how his early visits to the Louvre had contributed to strengthening that love for Classical art which would never be denied. "In the mind of the young painter" Rivière said, "a general theory of art was forming, of an unassailable logic, solidly grounded in the study of the ancients."

■ Piero della Francesca, *View of Arezzo*, detail from *Stories of the Cross*, c.1452–65, San Francesco, Arezzo. The houses in Cézanne's views of l'Estaque recall the work of this earlier master.

■ Cézanne, *Dying Slave*, after Michelangelo, c.1900, Philadelphia Museum of Art.

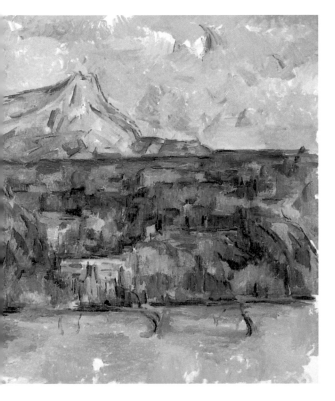

■ Cézanne, *Mont Sainte-Victoire Seen from Les Lauves*, 1902–06, The Nelson-Atkins Museum of Art, Kansas City. Cézanne preferred contours that were not clear-cut, but indistinct, that highlighted his difficult and perpetual study of color. He aimed to harmonize the exterior world and his state of mind to the point where they became as one.

■ Katsushika Hokusai, *A Pleasant Breeze and a Limpid Joy*, c.1830. The prints of Hokusai made the rounds of artists who were immediately enthusiastic. Pissarro in particular, was always interested in the graphic arts, and appreciated the technical aspects.

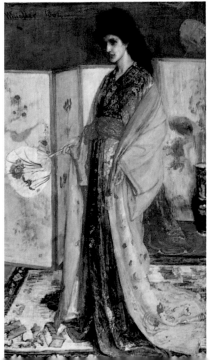

■ James Abbot McNeill Whistler, *The Princess in the Country of Porcelain*, 1865, Smithsonian Institution, Freer Gallery of Art, Washington. Fascinated from the beginning by Japanese art, Whistler began to collect blue and white porcelain and Japanese costumes, which he bought in a shop in the rue de Rivoli. The shop belonged to a couple called Desoye and was set up after their return from a long trip to Japan.

Still Life with Plaster Cupid

The statuette, the artist's own property, is of
uncertain origin and today can no longer be traced.
It did not appear in the sales which took place after
his death. The painting, executed from 1894 to 1895,
is now in the Nationalmuseum in Stockholm.

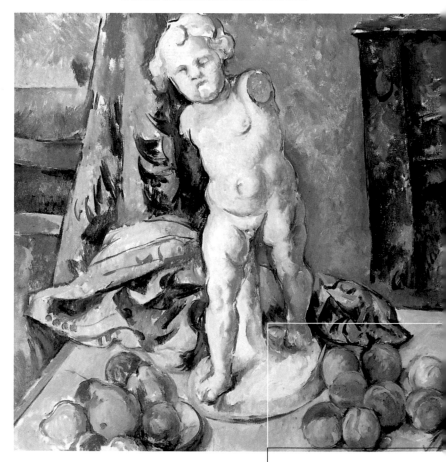

■ "He [Cézanne]
brought out three
still lifes…. Warm,
profound, alive, they
burst forth like magic
wall panels yet were
deeply rooted in
everyday reality"
(Joachim Gasquet).

■ Cézanne, *Plaster
Cupid*, 1890–1904,
one drawing and
two watercolors.
The drawing does not
seem to be a study for
the painting but is an
"unfinished" work. The
watercolors are interes-
ting for the study of the
twisting of the cherub.

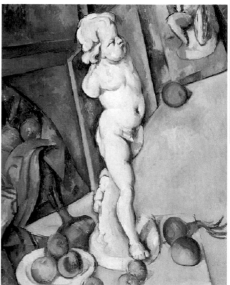

■ Cézanne, *Plaster
Cupid*, c.1895,
Courtauld Institute
Galleries, London.
In this composition,
Cézanne chooses
a vertical format
that emphasizes
the statuette.

■ Cézanne, *Still
Life with Apples
and Oranges*, Musée
d'Orsay, Paris. In most
of his still lifes Cézanne
used a white cloth to
give sculptural form to
the composition. Here,
he also used a rich
damask as a backdrop.

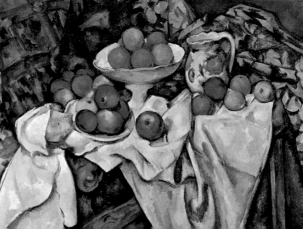

111

The Cardplayers

Cézanne created the series of Cardplayers paintings between about 1890 and 1896 and it is fascinating because he seems to want to reduce the scene to a still life. The characters depicted are enigmatic, reminiscent of masks, they do not communicate with the viewer, offering very little expression and a rigid pose. It is almost as though the painter, in depicting the cardplayers, has no access to their interior life. They represent perhaps the clearest and most mature example of Cézanne's originality, which is completely distinct from the treatment given to the same subjects in the past by other artists. Previously, figures like these had appeared in scenes of social life, of relaxation or depicting a simple hobby; or in scenes of greed, deceit, or anxiety. Not one of these aspects is manifest in this picture: the players are completely immersed in the cards and display no emotion whatsoever. The whole painting contrasts with the reality of a Provençal card game which is convivial and noisy. Cézanne, using his own style, transforms this typically lively moment into an intellectual experience.

■ Cézanne, *Peasant in a Blue Smock*, 1892 or 1897, Kimbell Art Museum, Fort Worth, Texas. Of uncertain date, this canvas confirms Cézanne's habit of using as models the peasants who worked the land around the Jas de Bouffan.

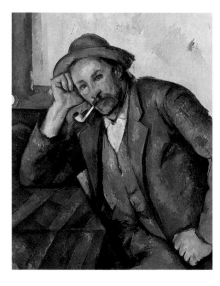

■ Cézanne, *Smoker*, 1891–92, Städtische Kunsthalle, Mannheim. The color modulation in this work is extremely refined, with subtle harmonies from blue to mauve.

■ Cézanne, *Cardplayers*, 1890–92, Private Collection. The drawing is brought to life by the use of chiaroscuro. Light and shade oscillate from the foreground to the background in a total dissolving of space.

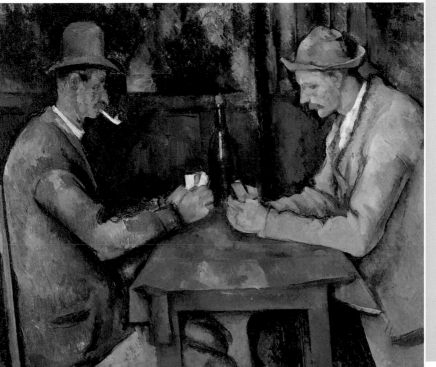

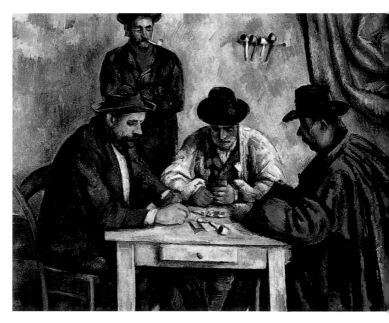

■ Cézanne, *Card-players*, 1893–96, Musée d'Orsay, Paris. In a letter that Cézanne wrote to Paul Alexis, the artist acknowledged that he never brought models together at the same time, preferring to arrange them in a scheme after studying the details.

■ Cézanne, *Card-players*, 1892, The Metropolitan Museum of Art, New York. Roger Fry said of the group: "(this) gives us so extraordinary a sense of monumental gravity and resistance – of something that has found its centre and can never be moved".

113

1890–1906

Woman with a Coffeepot

The woman is seated before a geometric background, against which the coffeepot and cup stand out. The treatment of her hair, hands, and dress give the portrait a monumental aspect. Painted in about 1895, the canvas is now in the Musée d'Orsay in Paris.

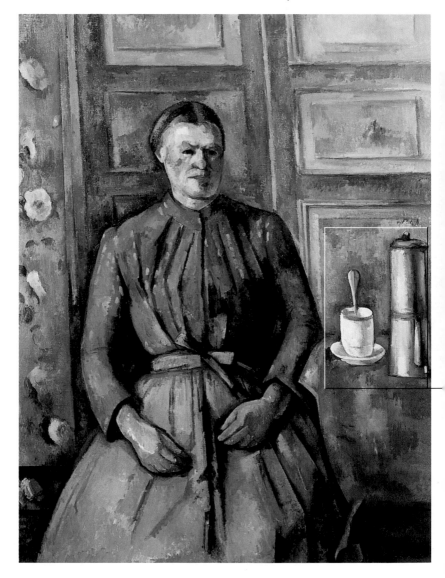

■ The detail of the spoon handle is used by the artist to force the whole painting to submit to his desire for "verticalization". These sophisticated spatial manipulations were to exert a profound influence on Cubist painters.

■ Cézanne, *Madame Cézanne in a Yellow Chair*, 1893–95, The Metropolitan Museum of Art, New York. Similar in approach to *Woman with a Coffeepot*, this portrait shows artist's wife seated by a patterned curtain and holding a rose.

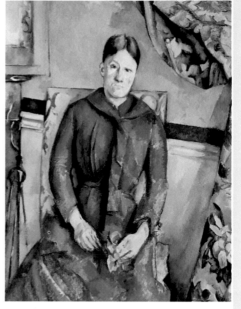

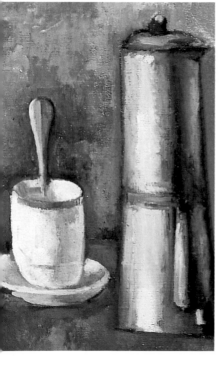

■ Cézanne, *Seated Woman*, c.1895, Jan and Marie-Anne Krugier-Poniatowski collection. From the blue dress, the hairstyle, and the pronounced chin, this watercolor seems to have been painted at the same time and with the same model as the Musée d'Orsay picture.

"Death is no longer absolute": the cinematograph

The cinematograph was presented for the first time on 28 December 1895. Early research was carried out by an eccentric personality, the photographer Antoine Lumière, who, with the help of his two sons, Auguste and Louis, perfected a technique of breaking down movement into a series of instantaneous photographs. The idea took the form of countless trials, up to the birth of a rudimentary cine-camera. The first demonstrations took place in private meetings, but the real challenge was attracting a vast paying

■ *Cinematograph*, watercolor attributed to Jules Chéret, 1896, Museo Nazionale del Cinema, Turin. At the sight of an advancing train, viewers recoiled into their seats.

public. Its success was almost immediate: the first spectators were dumbfounded, finding themselves confronted not by a theatrical performance, but by real life! A journalist of the time wrote: "when the use of this apparatus spreads among people and everyone is able to photograph their loved ones, no longer in a state of immobility but in movement, in action, in familiar gestures, speaking, then death will no longer be absolute."

■ *Drunk Attached to a Lamppost*, etching for magic lantern, 1800. Cinémathèque Française, Paris. Initially painted by hand, magic lanterns were later produced with chromolithography or photographs.

■ Monkeys looking inside a box theatre in an English engraving from the first half of the 18th century, Museo Nazionale del Cinema, Turin. Before cinema, one of the children's amusements at street fairs used to be looking inside "magic boxes", where the operator moved scenes lit by candles.

■ *The Kiss of May Irwin and John C. Rice*, Edison, 1896, Cinémathèque Française, Paris. Perhaps the very first cinema kiss, here as the only subject of a 16-metre film. The image is evocative of Rudolf Valentino, cinema's romantic idol.

■ Illustration of the use of the camera obscura to observe the solar eclipse, 1544. Ancient shadow-theatre had already formed the first steps towards the cinematograph. But it was perhaps with the advent of the camera obscura, studied by Leon Battista Alberti and Leonardo da Vinci, that photographic and later, cinematographic, experiments came into being.

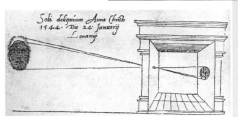

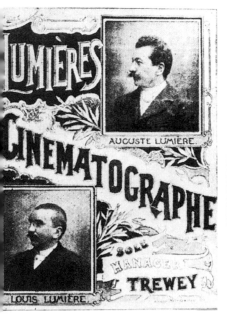

■ From the very first public shows in London the cinematograph was a great success, making a fortune for the organizer Félicien Trewey, who was a friend of the Lumière family. This is an English poster advertising the Lumière cinematograph.

■ *The Dream of a Rarebit Fiend*, E. S. Porter, Edison, 1906, British Film Institute, London. Ever popular comic fantasies took inspiration from the characters and scenery in comic strips. This image shows a drunk having nightmares.

Portrait of Gustave Geffroy

The portrait of the critic in his studio is an established genre. Manet painted Zola, Degas the critic Duranty in a very similar picture with bookshelves in the background and a table covered with books. Dated 1895 to 1896, the picture is now in the Musée d'Orsay in Paris.

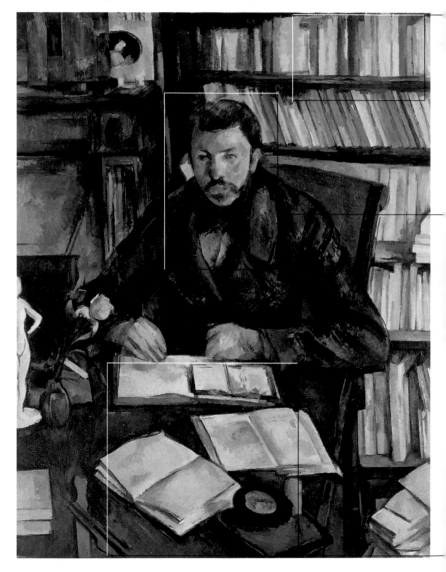

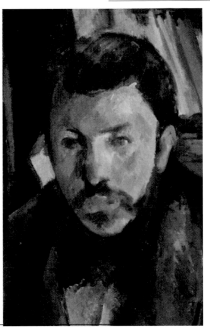

■ The books in the library were for Cézanne an important element in the study of space and in defining volumes rather than an emotive evocation. They are arranged vertically and slanting, great attention is paid to the chromatic effect, which perfectly conveys the coordination of the many different angles. Some angles are traced by the books on the shelves, others by the notebooks and papers on the table. All these details lend an astonishing structure to the painting.

■ The face and hands are sketchy, partly because the work remained unfinished, partly because Cézanne had no great affection for the critic who seemed to him too eclectic and with frivolous tastes. According to Joachim Gasquet, mild irritation eventually turned into very real hostility.

■ On the table lie papers, books, an inkwell, an artificial rose (which Cézanne had probably brought), and a Rodin statuette. When the Caillebotte collection was left in a bequest to the government, Geffroy was the first to write in praise of Cézanne in a national newspaper, *The Journal*.

1905: annus mirabilis, Einstein and the theory of relativity

"**T**here is nothing to grasp onto in the universe – as far as we know" wrote an anonymous writer and Einstein added in his own hand "read and approved". The theory formulated by Albert Einstein in 1905 opened the way for philosophical reflections that also had repercussions in non-scientific fields. A single theory brought together light and matter and therefore also space and time: two events that appear simultaneous to a passenger on a train are not so for an individual who sees the train passing; he sees one of the events happening before the other. Which of the two is right? Both, responded Einstein. In an interesting essay on Einstein, Roland Barthes wrote: "this is the myth of Einstein; all the gnostic themes are here: the unity of nature, the real possibility of a reduction of the world, the opening power of the formula, the ancestral struggle with a secret and a word.... Einstein fulfils the most contradictory dreams, he reconciles mythically the infinite power of man over nature and the 'fatality' of a sacred belief to which this can no longer submit." So did Cézanne really have defective eyesight as many have thought? Is it really foolish to see the world and reality so distorted?

■ Caricature of Einstein, Ippei Okamoto, American Institute of Physics, New York. According to the science historian Gerald Holton, Einstein often declared that he had always asked himself questions about space and time "to which only children are curious to know the answer (which only children do)".

■ Einstein in Zurich, photograph from 1912, E.T.H. Bibliothek, Zurich. Music, a passion inherited from his mother, occupied a very significant position in the scientist's life. He loved to play the violin and loved chamber music, which he played with other musicians whom he encountered on his travels.

■ Einstein's own formula, this postscript of the theory of relativity states that the mass of a body is linked to its energy content; this equivalence, according to which if a body absorbs energy the mass increases, and if it expends energy its mass diminishes, is without doubt his most famous formula.

■ Equations by Einstein on the theory of relativity, Princeton University Press, Boston University. "One thing I have learned…that all our science, if compared with reality, is primitive and infantile…and yet it is the most precious wealth we have" (Albert Einstein).

■ Einstein in front of NBC cameras, speaking out against the use of the H-bomb, photograph, Bild Archiv Preussischer Kulturbesitz, Berlin.

■ Black hole, artist's impression, Manchu, Ciel et Espace. The black hole represents a huge concentration of mass which distorts the surrounding space.

Ambroise Vollard

This portrait (1899) of his friend the art dealer is now in the Musée du Petit Palais in Paris. Vollard is within a cross-shaped structure, in a play of perpendicular lines formed by the background and the features of the face.

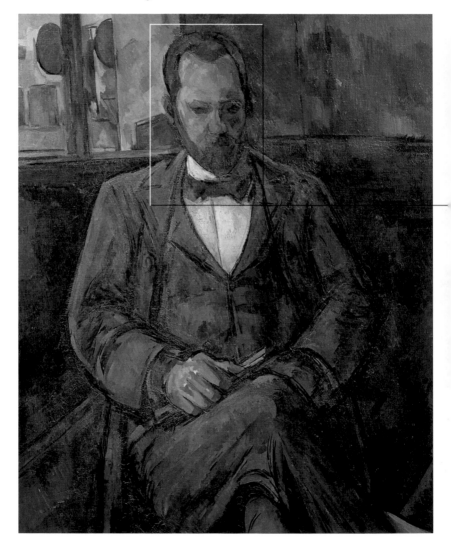

■ Cézanne, *Ambroise Vollard*, The Fogg Art Museum, Cambridge (Mass.). Prior to painting the portrait on canvas, Cézanne again made numerous sketches with his friend as subject. According to Vollard, this particular drawing was the starting point for the work in the Petit Palais.

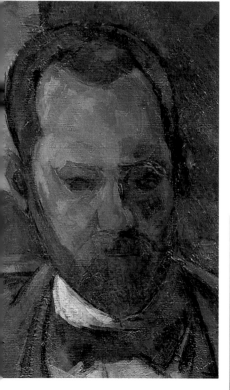

■ Maurice Denis noted in his diary the innumerable sittings undergone by Vollard for this painting. However, despite constant retouching, it retains the character of a sketch, particularly in the details of the head.

■ Cézanne, *Man with Crossed Arms*, c.1899, The Solomon R. Guggenheim Museum, New York. In general Cézanne was not interested in characterizing social class, mood, or the feelings of the people he portrayed, but rather in defining their look.

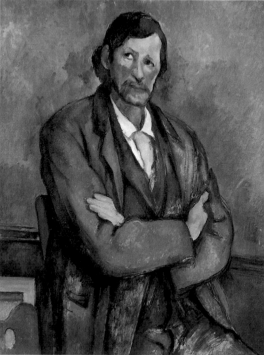

The Fauves

"**A** pot of paint has been thrown in the face of the public". A group of artists showed their work in public at the 1905 Salon d'Automne and were immediately dubbed the "fauves" (wild beasts). They were not a true school, but a group of artists responding to the sensitivities of the early years of the 20th century. Forms had to be simple, and colors pure, able to express subjective impulses, intellectual and sentimental tensions. Their common trait was their relationship with color, for them more determining than details, shadowing, or modelling. "The choice of colors" said Henri Matisse, "does not reside in any scientific theory. It is based on the experience of my sensitivity". This reflection contrasts with the parallel studies of the Cubists who saw themselves as an organized movement, with rules and defined aims. The Fauves included some exceptional people, from the brightness of Matisse to the classicism of Derain, from the dramaticity of Vlaminck to the intimacy of Vallotton. Primitive art and the sculptures of Africa and Oceania "discovered" in 1905 were, along with the art of Gauguin and van Gogh, their most frequent sources of inspiration.

■ Henri Matisse, *Interior in Nice, Mesdemoiselles Matisse and Darricarrère*, 1920, Le Musée de l'Annonciade, Saint-Tropez. As though in a photograph the two women are immortalized in a pause in conversation. In the bright light of the south; in the brilliance of the background details and in the flowers, the artist conveys the family atmosphere in the house.

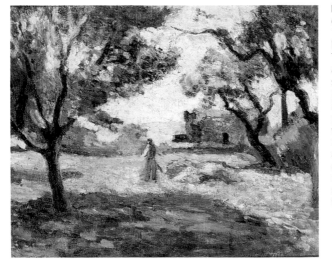

■ Henri Matisse, *Corsican Landscape*, 1898, Le Musée de l'Annonciade, Saint-Tropez. At this time, although he was still suffused with Impressionist culture, Matisse already perceived that color was no longer the means of arriving at a "truthfulness" of atmosphere and natural light, but an end that created the picture itself.

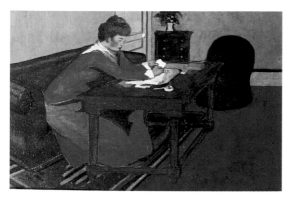

■ Félix Vallotton, *Misia at the Desk*, c.1897, Le Musée de l'Annonciade, Saint-Tropez.

■ Maurice de Vlaminck, *Still Life*, 1907, Le Musée de l'Annonciade, Saint-Tropez. The artist concentrated on vigorous and schematic painting of landscapes and still lifes, and was the most radical of the group.

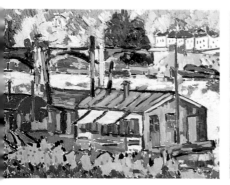

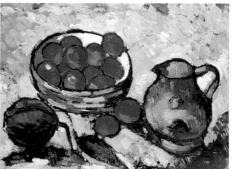

■ Maurice de Vlaminck, *Pont Chatou*, 1906, Le Musée de l'Annonciade, Saint-Tropez. By his own nature, incapable of reinventing himself or accepting any critical revision of his own emotional approach, Vlaminck would never again repeat the results of these years.

■ André Derain, *Bridge over the Thames (St Paul's and Waterloo Bridge)*, 1906, Le Musée de l'Annonciade, Saint-Tropez. For Derain 1906 and 1907 were particularly happy years from the artistic point of view. The views of London are among his most beautiful paintings.

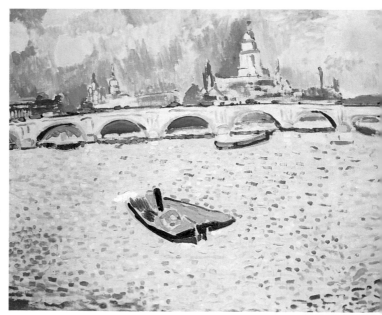

1890–1906

Les Grandes Baigneuses

Painted in 1906, this picture is now in the Philadelphia Museum of Art. It shows a group of women bathing beneath trees in a field. The theme was a recurring one, and over the years Cézanne produced about 30 sketches and numerous drawings and watercolors.

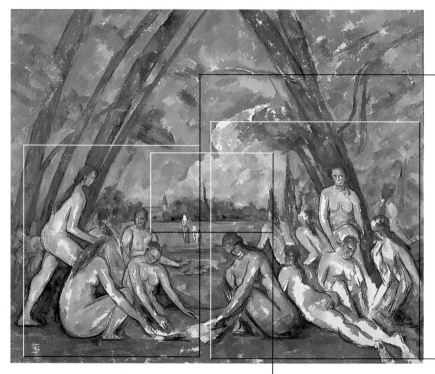

■ The pictorial framework of this painting is, compared with other paintings on the same subject, wider, opening up to a horizon which is more clearly visible than in other versions. Here the sky seems to want to give the figures the breath they need to move freely. The colors are ochre, white, violet, green, and, on the faces of the girls, a touch of vermilion.

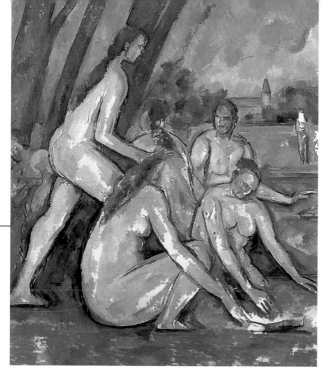

■ In a solidly monumental structure, Cézanne seems to have the isosceles triangle in mind, within which he depicts groups of figures, each one viewed from a different angle. The groups themselves form smaller triangles, with the longer sides traced by limbs and branches.

■ Pablo Picasso, *Les Demoiselles d'Avignon*, 1907, The Museum of Modern Art, New York. Picasso made a serious study of Cézanne's work, adding his own interpretation. There are similiarities between this and Cézanne's *Bathers*.

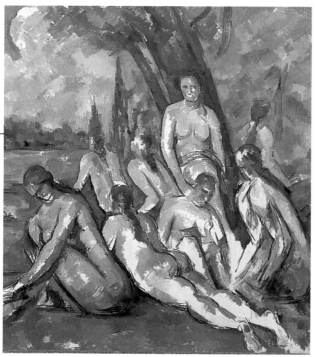

■ The deliberately elongated forms of the women echo the work of past masters, but the patchy spread of transparent color and the areas left white for highlights, place the figures in a timeless dimension, identifiable in any era.

127

1890–1906

The final muse: Mont Sainte-Victoire

■ Mont Sainte-Victoire, to the northeast of Aix. The mountain is visible from various viewpoints but the road to Le Thonolet, which Cézanne often took, passes closest to it. En route is Château Noir, a farm outside Thonolet.

As Cézanne grew older he withdrew into an increasingly small world even though, following his father's death, he could have enjoyed a fortune that would have enabled him to travel and live in comfort. The artist continued to opt for a quiet, simple life, constantly in search of pictorial motifs in the area around Aix, which continued to exert a great fascination. Among his favorite themes was Mont Sainte-Victoire, which lay a few kilometers east and which he had painted a number of times in the past, albeit in a more legible way. Now however, although the views keep their shapes, which remain recognizable, they have become more rarefied and abstract, more distant. The "muse Victoire" accompanied Cézanne to the end. He was taken ill during a storm while he was painting. It was October 15, 1906. A few days later, on October 23, he died from lung congestion.

■ Maurice Denis, *Visit to Cézanne*, 1904, Private Collection. In this little oil sketch Denis records his visit to Cézanne in January 1906, in the company of his friend Ker-Xavier Roussel.

■ Cézanne, *Mont Sainte-Victoire Seen from Les Lauves*, Private Collection, Philadelphia. This was the only water-color of the mountain in portrait format.

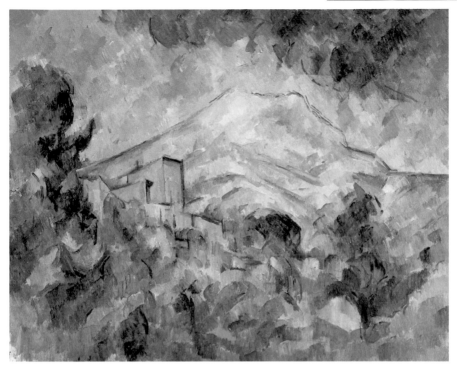

■ Cézanne, *Mont Sainte-Victoire and Château Noir*, 1904–06, The Bridgestone Museum of Art, Tokyo. Around the mountain is a vortex of color that confuses the clouds with the trees, leaving only the light illuminating the house.

■ Cézanne, *Mont Sainte-Victoire seen from the road to Le Thonolet*, c.1900, The State Hermitage Museum, St Petersburg. In his continued studies of form it seemed as though Cézanne wanted to reconcile the earth with the sky in one great single sensation.

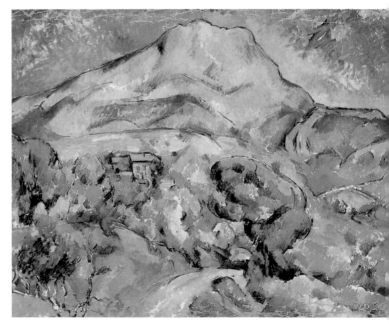

1907: a great commemorative exhibition

At the Salon d'Automne of 1907 a large retrospective exhibition was organized, it brought together 56 paintings by Cézanne. Visitors to the Grand Palais included Picasso, Matisse, the poet Apollinaire, Braque, and the Italian painter Ardengo Soffici who subsequently wrote articles on the subject which were published in Italy. The painter Emile Bernard wrote a two-part piece on his memories of Cézanne in *Mercure de France*. Writers were fascinated; Gertrude Stein, who owned an important collection of Cézanne's work, claimed to have drawn inspiration from the painting *Madame Cézanne in a Red Armchair* for her stories in *Three Lives*. Emile Bernard in 1915, again in *Mercure de France*, wrote: "He was the definitive independent in search of the absolute. He was not understood because it pleased him to be misunderstood". The poet Rilke, in his *Letters on Cézanne*, written after visiting the Salon d'Automne, wrote: "All the reality there is from him: in that dense muted blue, which is his, in his red, in his shadowless green, in the reddish-black of his wine bottles".

■ A passionate student of art history, the poet Rainer Maria Rilke (pictured above) met his future wife, the writer Clara Westhoff, at Bremen. In one of his extraordinary *Letters on Cézanne*, he wrote to her: "this unexpected meeting, the way it happened and took place in my life, gave me a great feeling of rapport and affirmation of myself."

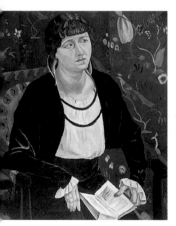

■ André Derain, *Portrait of Madame Kahnweiler*, 1913, Musée National d'Art Moderne, Centre Georges Pompidou, Paris. Following his experiences of the Fauves and Cubism, Derain took up a more classicizing position in about 1913.

■ Pablo Picasso, *The Road in the Woods*, 1908, Civico Museo d'Arte Contemporanea, Milan. In his early days, Picasso was acutely conscious of the lessons of Cézanne; he read the numerous letters sent by the artist to his son and to the painter Bernard in which he expounded his theories on a formal alteration of the image.

■ Pablo Picasso,
*House in a Garden
(House and Trees)*,
1909, Pushkin Museum,
Moscow. In Picasso's
painting, colored,
geometric forms follow
one another without
any relief. The image's
composition is similar
to elements in Cézanne's
work. The forms in
the Picasso painting
do not give any illusion
of depth and are simply
positioned one beside
the other.

■ André Derain,
Trees, c.1912, Pushkin
Museum, Moscow.
After initial enthusiasm
for color, Derain
developed a vision
tending to a certain
primitivism. Apollinaire
considered him to be
one of the founders
of the Cubist aesthetic.

Cubism

The retrospective of 1907 was of fundamental importance, in particular for Picasso, Braque, and Fernand Léger. In fact Léger declared: "Without Cézanne I sometimes ask myself what would be the state of painting today. For a long time I have worked with his oeuvre". And in effect Cézanne's efforts to create space through volumes were to be fundamental for Cubist artists. The term Cubism came from the critic Louis Vauxcelles who, reviewing a Braque exhibition, spoke of the tendency of the painter to reduce everything to cubes.

INDEX

■ Cézanne, *Chestnuts at the Jas de Bouffan*, c.1871, Tate Gallery, London.

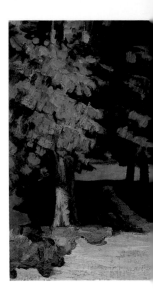

Note

The places listed in this section refer to the current location of Cézanne's works. Where more than one work is housed in the same **place***, they are listed in chronological order.*

■ Cézanne, *Woman Diving into the Water*, 1867–70, National Museum and Gallery of Wales, Cardiff.

■ Cézanne, *Road through the Fields,* 1876–77, Private Collection.

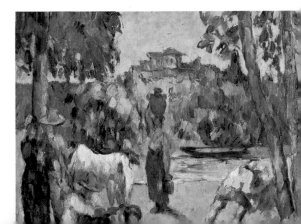

■ Le Pont de la Cible
sur l'Arc, near Aix-en-
Provence, postcard
at the time of Cézanne.

Aix-en-Provence — Le Pont de la Cible sur l'Arc

Collection C. M.

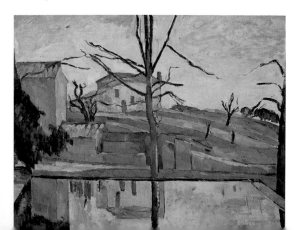

■ Cézanne, *Pool at the
Jas de Bouffan*, 1878,
Private Collection.

■ Cézanne, *Poplars*, 1879–80, Musée d'Orsay, Paris.

■ Cézanne, *Young Man Leaning on his Elbow*, 1866, Private Collection.

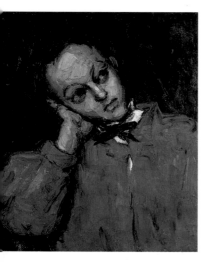

■ Cézanne, *Rocks at l'Estaque,* 1879–82, Museu de Arte, São Paulo.

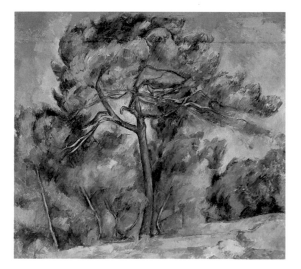

Note

*All the names mentioned
here are artists, intellectuals,
politicians, and businessmen
who had some connection with
Cézanne, as well as painters,
sculptors, and architects who
were contemporaries or active
in the same areas as Cézanne.*

Alexis, Paul, follower of, and
later secretary to, Emile Zola,
pp. 19, 68, 113.

Apollinaire, Guillaume
(Rome, 1880 – Paris, 1918),
French poet, writer, and critic.
Constantly at the centre of
discussions on the avant-garde
of the 20th century, he was the
first to support the Fauves, p. 130.

Bernard, Emile (Lille, 1868 –
Paris, 1941), French painter
and writer. A shrewd connoisseur
of art, he was one of the first
to understand and value the
paintings of van Gogh and
Cézanne, to whom he dedicated

a book of reminiscences in 1912.
In opposition to the realism of
the Impressionists, he adhered
to Symbolist theories, becoming
the critical conscience of the
movement. After 1905 he dis-
owned Symbolism and took up
a more academic, eclectic style
of painting, with Neo-Renaissance
ambitions, pp. 90, 91.

Braque, Georges
(Argenteuil, 1882 – Paris, 1963),
French painter. Together with
Picasso, he of the most important
exponents of Cubism, pp. 54, 130.

Campigli, Massimo (Florence,
1895 – Saint-Tropez, 1971), Italian
painter. In 1919, as the Paris
correspondent of *Corriere della
Sera*, he began to paint in an
atmosphere of Post-Cubist and
purist study, focusing on Seurat,
Léger, Picasso, and primitive and
Egyptian art, demonstrating his
interest in the archaic and a
balanced simplicity in formal
layout. He achieved European
fame in 1929 with a show at the
Boucher gallery in Paris, p. 79.

Cézanne, Louis-Auguste,
father of Paul, pp. 8, 16, 42, 82.

Cézanne, Marie, sister to
Paul, and their father's favorite
child, pp. 8, 82.

Cézanne, Paul, son, from his
relationship with Hortense
Fiquet, pp. 42, 43, 48, 54, 83, 89.

Constable, John (East
Bergholt, Suffolk, 1776 – London,
1837), English painter. Mainly
interested in landscapes, he
studied the classic landscape
artists (Lorrain, Poussin, Dughet)
but also 17th-century Dutch
painters and other English artists.
He frequently painted from real
life, moving from sketches to
drafts to the final painting. Some
of his pictures, shown at the
Paris Salon of 1824, achieved
great success and influenced,
among others, Delacroix, p. 48.

Daumier, Honoré (Marseille,
1808 – Valmondois, 1879), French
sculptor, lithographer, and painter.
At first he mainly devoted himself
to lithography, publishing notable
satirical vignettes, then later to
sculpture and painting. His

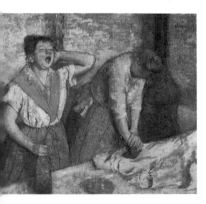

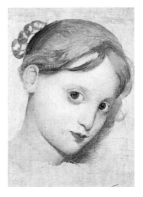

■ Dominique Ingres, *Laure Zoega*, 1813, Musée du Louvre, Paris.

■ Dominique Ingres, *Laure Zoega*, 1813, Musée du Louvre, Paris.

of movement, pp. 48, 58, 62, 67, 74, 75, 106, 118.

Delacroix, Eugène (Charenton-Saint-Maurice, 1798 – Paris, 1863), French painter. His Romanticism found expression in the dynamic force of his compositions. A long trip to Morocco and Algeria served to deepen his interest in the effects of light, pp. 23, 61, 108.

Derain, André (Chatou, 1880 – Garches, 1954), French painter. One of the Fauves in their early days, he later devoted himself to greater realism, pp. 124, 125, 130, 131.

Durand-Ruel, Paul (Paris, 1831 – 1922), French art dealer and gallery owner. From 1870 he conducted a passionate battle on behalf of Impressionist painters, supporting the work through his famous gallery, p. 48.

Emperaire, Achille, painter whose portrait was painted by Cézanne, pp. 17, 28, 29.

blistering way with a pencil, plastic and incisive, brought him not a few problems with censorship. From 1860 onwards he preferred to paint, using figurative work to comment on daily events and on the world of the poor. He used color that was dense and velvety, in which dull tonalities predominated, pp. 36, 37, 98.

Degas, Edgar (Paris, 1834 – 1917), French painter. Son of a banker, he moved away in part from a bourgeois environment when he became acquainted with Manet and the Impressionists. He exhibited work at the first show held by the group in 1874, but nonetheless preserved a distinct individuality: he did not love to "immerse himself in nature" and preferred instead to study urban interiors and the female figure – his ballerinas are pure studies

Fiquet, Hortense, wife of Paul Cézanne, pp. 42, 43, 48, 54, 64, 82.

Gachet, Paul-Ferdinand, homeopathic doctor, art lover, and friend of Pissarro and Cézanne, p. 50.

Gauguin, Paul (Paris, 1848 – Marchesas Islands, 1903), French painter. His style, characterized by an extraordinary figurative richness, influenced the Nabis and in many ways anticipated Expressionism, pp. 73, 90, 91, 106, 124.

Granet, François-Marius (Aix-en-Provence, 1775 – Malvallat, 1849), French painter. Pupil of David and friend of Ingres. After an early Neoclassical phase he developed an interest in historical and medieval subjects. He was above all a significant landscape

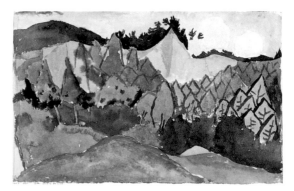

■ Paul Klee, *In the Quarry*, 1913, Klee Foundation, Bern.

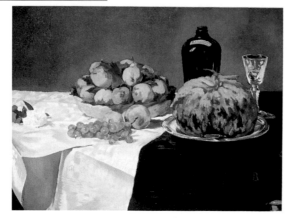

■ Edouard Manet,
*Still Life with
Watermelon and
Peaches*, c.1866,
National Gallery
of Art, Washington.

painter: his preferred subjects were views with ruins, church interiors, and abandoned cloisters, pp. 9, 14.

Huysmans, Joris-Karl (Paris, 1848 – 1907), French writer, author of *A rebours*. Huysmans enthusiastically supported Cézanne, pp. 68, 69, 73, 78.

Ingres, Dominique (Montauban, 1780 – Paris, 1867), French painter. Pupil of David in Paris, initially he was shunned by academic circles, but was subsequently acclaimed, even in academia, as the greatest living artist, and received numerous awards. For a century he was regarded as the emblem of Classicism in contrast to the Romanticism of Delacroix. He has recently been the subject of more detailed critical appraisal which has highlighted, apart from his undoubted technical capability, his tireless formal study, p. 15.

Klee, Paul (Münchenbuchsee, 1879 – Muralto, 1940), Swiss painter. Klee was an artist of multifaceted formation, with lively interests in music and literature. In 1908 in Paris he was able to see work by van Gogh and Cézanne, the "master par excellence". From this experience and from his active participation in the key artistic movements of the 20th century, he extracted a rapport, rigorous and constantly enriched, between theory and pictorial practice, which was translated into a figurative language capable of recreating nature through the continued discovery of new forms, p. 55.

Léger, Ferdinand (Argentan, 1881 – Gif-sur-Yvette, Seine-et-Oise, 1955), French painter. Having taken Post-Impressionist painting and Cézanne as his starting point, he was drawn to the methods of the Fauves and attempted a more advanced breakdown of the image in the Cubist sense. Subsequently he built up compositions using mechanical elements, which expressed his interest in industrial civilization and the world of work, p. 131.

Lumière, family, inventors of the cinematograph. In 1895 they patented the apparatus and in the same year organized the first showings. They later sent their operators abroad to publicize the invention, p. 116.

Manet, Edouard (Paris, 1832 – 1883), French painter. A point of reference for Impressionist painters, he was bitterly opposed

■ Henri Matisse, *Interior at Collioure*, 1905, Private Collection.

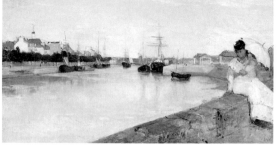

■ Berthe Morisot,
The Harbour at Lorient,
1869, National Gallery
of Art, Washington.

by the circle surrounding
"official" art because his art
dealt with subjects considered
unacceptable, abolishing
the treatment of volumes,
perspective, of mezzotints and
chiaroscuro, in order to use flat
colors only, strongly contrasted.
Each of his pictures is a problem
of form resolved with color and
line, pp. 19, 20, 26, 27, 33, 48, 52,
53, 58, 63, 75, 87, 118.

Matisse, Henri (Le Cateau,
1869 – Cimiez, 1954), French
painter and sculptor. Starting out
by studying Corot, Vermeer, and
Fragonard, he later "metabolized"
the Impressionist experience of
using color as an atmospheric
means so as to reach a "pure"
use of color in order to obtain
a visual sensation of impact with
the painted image. A key figure
among the Fauves (1905), he was
subsequently drawn to Cubism
and in later life to Abstraction,
pp. 39, 101, 106, 124, 130.

Monet, Claude (Paris, 1840 –
Giverny, 1926), French painter.
A member of the Impressionist
movement from the very
beginning, it was his painting
Impression: Soleil levant (1872)
that gave its name to the
new style. The laws of
complementary colors

and of light and color were
continually worked on and
he made infinite variations
on the same theme. From
the theoretical point of view
he expressed his conviction
that the artist, confronted by
the subject to be painted, should
identify him- or herself with
it, abolishing the distinction
between sense and intellect,
pp. 38, 49, 58, 59, 62, 66, 98.

Moore, Henry (Castelford,
Yorkshire, 1898 – Much Hadham,
Hertfordshire, 1986), English
sculptor. By means of a very slow
process of evolution, including the
study of natural forms, of ancient,
classical, Renaissance and
Impressionist art, he achieved a
formal synthesis of the comple-
mentary nature of matter and
space, where cavities acquired the
same value as mass, pp. 56, 57.

Morisot, Berthe (Bourges, 1841
– Paris, 1895), French painter. A

pupil of Corot and sister-in-law
to Manet, between 1875 and 1886
she took part in almost all the
Impressionist exhibitions, tending
in later years towards a greater
solidity and determination
of forms, p. 58.

**Nadar (Tournachon,
Gaspard-Félix)** (Paris,
1820 – Marseille, 1910), French
photographer. A caricaturist,
he was drawn to photography in
order to carry out his project
of assembling a collection of
caricatures of the most important
personalities of the time, the
Pantheon. He went on to become
the preferred portraitist of
Parisian intellectuals and
carried out important reportages,
among them one from a hot air
balloon. In 1874 his studio in
the Boulevard des Capucines
hosted the first Impressionist
exhibition, pp. 32, 36, 75.

Père Tanguy, paint seller and
art dealer. He was Cézanne's
dealer, p. 106.

Picasso, Pablo (Malaga, 1881 –
Mougins, 1973), Catalan sculptor
and painter. After various
artistic periods (the
"blue" and "rose"
periods), study of
Cézanne and African

■ Henry Moore, *Family
Group*, 1948–49, The
Henry Moore Founda-
tion, Hertfordshire.

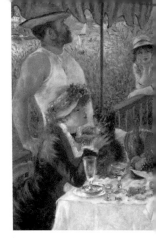

■ Pablo Picasso,
The Kiss, 1925, Musée
Picasso, Paris.

art led him to produce *Les
Demoiselles d'Avignon*, a work
that brought about the birth
of Cubism. He followed artistic
trends in contemporary art,
from the Classicism of the
1920s to the Surrealism of the
1930s. He produced numerous
sculptures in bronze or from
salvaged everyday objects.
Towards the end of his life
he devoted himself to ceramics
and engraving, pp. 38, 65, 70, 97,
103, 106, 107, 127, 130, 131.

Pissarro, Camille (Saint-
Thomas, 1830 – Paris, 1903),
French painter. He exerted a
decisive influence on Cézanne
and on the other Impressionists,
encouraging them to ban bitumen,
black, and burnt sienna from
their palettes and to work "on one
motif". He showed paintings at all
the Impressionist exhibitions and
encouraged young talents like
Gauguin, Seurat, and Signac,
pp. 22, 30, 47, 48, 49, 50, 51,
58, 62, 66, 70, 106, 109.

Redon, Odilon (Bordeaux,
1840 – Paris, 1916), French
painter, engraver, and sculptor.
Representative of a current
that emerged in different ways as
the antithesis of Impressionism.
Controversially he refused to use
color until 1890, using his drawings
and lithographs as a means of
exploring a fantastic interior world.
His is an extremely personal
iconography, based on the
grotesque and the chimeric, p. 78.

Renoir, Pierre-Auguste
(Limoges, 1841 – Cagnes-sur-
Mer, 1919), French Impressionist
painter. To Courbet's realism he
added a predilection for everyday
subject matter, studying in

particular the effects of light,
pp. 48, 58, 61, 66, 92, 93, 99, 106, 108.

Seurat, Georges (Paris,
1859 – 1891), French painter and
exponent of pointillism. The work
Sunday at the Grande-Jatte is
regarded as his manifesto, p. 79.

Signac, Paul (Paris, 1863 –
1935), French painter. With
Seurat he developed pointillism.
In 1899 he published *D'Eugène
Delacroix au néo-impressionisme*,
in which he expounded his
theories of divisionism, pp. 78, 79.

Sisley, Alfred (Paris, 1839 –
Moret-sur-Loing, 1899), French
painter. From 1874 he took part
in Impressionist exhibitions.
Manet was his master but he
was also influenced by the
paintings of Constable and
Turner, absorbing from them
a use of color which was not
just sensual, but also rational
and programmed, p. 58.

■ Paul Signac, *Portrait
of Félix Fénéon in 1890*,
1890, Private Collection.

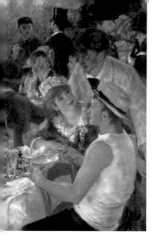

■ Pierre-Auguste Renoir, *Luncheon of the Boating Party*, 1880–81, Phillips Memorial Gallery, Washington.

■ Vincent van Gogh, *Farmhouse in Provence*, 1888, National Gallery of Art, Washington.

A DK PUBLISHING BOOK
Visit us on the World Wide Web at http://www.dk.com

TRANSLATOR
Fiona Wild

DESIGN ASSISTANCE
Joanne Mitchell

EDITORS
Jo Marceau, Peter Jones

MANAGING EDITOR
Anna Kruger

Series of monographs
edited by Stefano Peccatori and Stefano Zuffi

Text by Silvia Borghesi

PICTURE SOURCES
Archivio Electa, Milan
Archivio Scala, Antella, Florence
Alinari, Florence
Elemond Editori Associati wishes to thank all those museums and
photographic libraries who have kindly supplied pictures, and would be pleased
to hear from copyright holders in the event of uncredited picture sources.

Project created in conjunction with
La Biblioteca editrice s.r.l., Milan

First published in the United States in 1999 by DK Publishing Inc.
95 Madison Avenue, New York, New York 10016

ISBN 0-7894-4145-4

Library of Congress Catalog Card Number: 98-86750

First published in Great Britain in 1999
by Dorling Kindersley Limited,
9 Henrietta Street, London WC2E 8PS

A CIP catalogue record of this book is available from the British Library.

ISBN 0751307327

2 4 6 8 10 9 7 5 3 1

Printed by Elemond s.p.a. at Martellago (Venice)